YEOVIL CINEMAS

THROUGH TIME

Jane Duffus

AMBERLEY PUBLISHING

About the Author

Jane Duffus is an editor and events promoter. She grew up in Yeovil and, after ten years as a journalist in London, now lives and works in Bristol. She is a committed cinephile and has studied the history of cinema since A level and through three subsequent degrees (one BA and two MAs). Jane lists her five favourite films as *Gregory's Girl*, *Billy Liar*, *Pretty In Pink*, *Withnail & I* and *The Wizard of Oz*; for which she knows the complete script off by heart. Jane firmly believes there is no greater thrill than seeing one of your all-time favourite films on a cinema screen for the very first time.

Acknowledgements

Huge thanks to Joseph Lewis at the Yeovil Community Heritage Centre, who gave up an enormous amount of time and experience to help with my research. Additional thanks to: Rob Baker, David Brooke, Ben Doman, Paul Duffus, Allen Eyles, Colin Mayes, Richard Norman, Nigel Ostrer, Clive Polder, Simon Rexworthy, Charlotte Stock, Jack Sweet, and Kieran and Terry at Neo.

First published 2013

Amberley Publishing
The Hill, Stroud
Gloucestershire, GL5 4EP

www.amberley-books.com

Copyright © Jane Duffus, 2013

The right of Jane Duffus to be identified as the Author of this work has been asserted in accordance with the Copyrights, Designs and Patents Act 1988.

ISBN 978 1 4456 0948 5

British Library Cataloguing in Publication Data.
A catalogue record for this book is available from the British Library.

Typeset in 9.5pt on 12pt Celeste.
Typesetting by Amberley Publishing.
Printed in the UK.

Introduction

Cinemas

Have these palatial buildings become architectural dinosaurs? Or do they stand as historically and culturally significant temples of escapism and luxury that should be celebrated and preserved for future generations of film fans? There's no prize for guessing which answer I'd go for.

Writing in 1982, when cinema-going was well and truly in the doldrums, Neil Norman said in *The Face*, 'Film-going used to be a cheap way of receiving lavish treatment while being entertained. Uniformed attendants waited by every exit to show the audience in and out with a deference that boosted the ego and acted as a palliative for the acres of the real world outside.' He added sadly, 'A trip to the cinema ... no longer inspires a sense of occasion and current prices too often mean it has become a special treat more than an habitual form of entertainment.'

In *Yeovil Cinemas Through Time* I shall show how the footprint of Hollywood is firmly stamped upon the seemingly sleepy market town of Yeovil in Somerset. While writing this book, I was asked by people what there could possibly be to say of interest about the cinemas of Yeovil when there were only ever two cinemas in the area (the old Odeon and the current Cineworld)? By the time I told them about the Art Deco Central, the Army-run Globe and Ronnie Biggs robbing the Odeon, they started to change their minds. And there's so much more to say.

Despite its beginnings as a novelty entertainment, cinema stood its ground and became one of the largest mass-entertainment industries in the world. This book celebrates the 'night architecture' that was built to house the glittery strands of Hollywood as they dipped and weaved across the world, illuminating even the sleepiest of English towns.

In cinema's heyday, during the 1920s and 1930s, movie-going was more than just seeing a film – it was also about the experience of going out with friends or lovers to relax in a plush theatre, in a space that could transport you to anywhere in the world ... or even the universe. You really did go to the pictures for an experience that the soulless, sticky multiplex just can't replicate.

When I conducted an oral history in 2009 of people who had used the various cinemas in Yeovil over the decades, only a few of the many memories I heard were about the films people had seen; most of them were stories surrounding their cinema trip, their memories of the buildings or staff, or who they had gone with.

A Condensed History of UK Cinemas

The UK's first purpose-built cinema opened in 1909, and was swiftly followed by hundreds more. Most proto-cinemas were rectangular halls with barrel-vaulted roofs, decorative plasterwork and flamboyant façades. Today, a handful of these early cinemas are still in operation – with three vying for the title of the UK's oldest, continually-run cinema.

The first film fan magazine, *Photoplay*, was launched in 1912, followed by *Film Flashes*, *Pictures* and *Picturegoer*, along with trade magazines *Bioscope* and *Kinematograph & Lantern Weekly*. Feature-length films first appeared in 1913, and by the end of 1914 there were 4,000 cinemas across the UK. Cinema attendance was so healthy by 1915 that the need to offer a variety bill was gone.

There were very few circuits (or chains) initially, except for Albany Ward and Provincial Cinematograph Theatres in England, and George Green's chain in Scotland. Admission prices ranged from 2*d* for a bench in the stalls to 1*s* for a tip-up seat in the balcony. When you consider that in the early 1900s the UK population was 44 million, and that cinema attendance for this period was close to 20 million, you can clearly see the phenomenal popularity of this new activity. Cinema attendance peaked at 1.6 billion in 1946, which is equivalent to every man, woman and child in the UK going to the movies 33 times that year alone.

However, many cinemas closed for good during the First World War when projectionists were drafted, and the 1916 Amusement Tax Entertainments Duty took away the cheaper tickets and stopped cinema from being so affordable for everyone. Things weren't helped by a ban on luxury buildings in the 1920s, as the post-war economy focused on funding housing rather than entertainment. When cinemas finally re-emerged, they were clearly influenced by the new-style American cinemas – they were bigger, grander and more indulgent than ever before.

Things were changing by 1927, as new cinemas started to appear all over the country. As a result of the talkies, many existing cinemas also needed to undergo overhauls in order to accommodate the new sound systems, and they took the opportunity to revamp their buildings in increasingly exotic and exciting ways so as to compete with the fashionable American- and Egyptian-style cinemas.

 The Modern Movement of 1934 introduced a more contemporary image, and the fin towers that would later identify Odeon cinemas started to appear. These Odeons were a departure from the previously conceived cinema buildings – those associated with opulence and fancy dress. Instead, they were clean, streamlined and beautifully modern – functional buildings purpose-built for watching films.

The total number of operating cinemas in the UK reached 4,901 in 1939. Cinemas offered a relatively safe haven from air raids and were a surviving source of entertainment for depressed Brits. However, the Second World War put another stop to cinema construction, and cinema-circuit owners found that the large city-centre sites they wanted were being snapped up by shop developers eager to build department stores.

CinemaScope was introduced in 1953. This required many cinemas to widen their proscenium arches, or to erect new screens in front of their arches. The number of cinemas also began to decrease, partly because the quantity of Hollywood films available reduced after the Second World War, but also because television was taking off, with three television stations available by 1964. The introduction of Saturday morning children's programmes also spelled the end for children's Saturday cinema clubs.

UK cinema attendance halved between 1956 and 1960, from 1,101 million to 501 million. In the same period more than 1,000 cinemas shut down. Rising standards of living put cinemas out of business; people had less reason to escape their once-dreary homes. For instance, some

patrons in the 1930s had never stepped on a carpet until their first visit to a super-cinema, but post-war comforts meant many people now had carpets at home. Just one-third of households had a television in 1955, but fifteen years later, more than nine in ten households owned one. Cinema could not compete and admissions fell by 85 per cent over the same period.

During the 1960s it became clear that most cinemas were too large. It was uneconomic to maintain them, and depressing for audiences to be scattered thinly throughout a large theatre. Many one-screen cinemas were tripled, and some were divided between cinema and bingo uses. Sometimes the dual-screen meant a second cinema in the same town or city went out of business. New projectors could virtually run themselves, meaning the job of projectionist no longer needed specialist skills. Now that patrons were being spoilt for choice by television, newsreels, cartoons and double bills were phased out, so that the typical cinema bill simply had a main feature; the much-loved continuous showing of a film was dropped. Most of these conversions were not successful; they resulted in reduced sightlines and dampened ambience. Combined with the rise in prices, audiences felt cheated.

In 1970, cinema attendance was 193 million. Across the same period, the number of UK cinemas fell from 3,034 to 1,529. There was a brief rise in film attendance in 1978, thanks to *Star Wars*, but cinemas were still closing everywhere. This trend continued into the early 1980s when the arrival of video recorders offered another way to watch films at home. By 1984, annual attendance was just 58 million: less than one trip per person over the whole year.

Multiplex cinemas arrived in the UK in 1985, and prompted a rise in attendance to 71 million. Within a decade, multiplexes accounted for 10 per cent of all UK cinema sites and held a 46 per cent share of admissions. From 1995, the building of multiplexes rapidly increased and admission rose to 124 million by 1994. In 2011, total cinema admissions in the UK were 172 million.

Welcome to Yeovil

The first film licence in Yeovil was granted in 1896 for the Assembly Rooms, and Yeovilians were on top of the game – because the very first public film screening in the UK was also in 1896, albeit in London. In the subsequent 116 years, Yeovil has seen seven cinemas – not bad going for a town with a population of approximately 40,000 people in 2012. And the town has been home to one of the most prominent cinema architects the UK has produced.

Local historian Jack Sweet has spent much of his life in Yeovil, and remembers well the heyday of cinema-going in the town:

> The cinema was the people's entertainment. In the 1940s, 1950s and into the 1960s, it was incredibly busy … you had to queue to get into cinemas. The South Street entrance to the Gaumont had awning on it, and I saw queues all the way up South Street. Cinema was an entertainment – when it was Saturday night, there was only a choice between dancing and the cinema. The Odeon or Gaumont were equally great on film choices. The accommodation in both was plush, and even the Central was reasonably comfortable. But at the end of the 1940s, the Odeon and Gaumont were still only about ten years old and they were excellent, there's no doubt about that. I remember the doorman in uniform and peaked cap, and the ladies ushering people to their place.

Why do I care enough about the cinemas in Yeovil to have researched and written this book? Simply, I love films. I have studied them academically for more than half of my life and I love the beautiful buildings they are shown in.

Having spent the first eighteen years of my life in the town, Yeovil provided me with my first experiences of cinema-going: I was five in 1983 when I went with my older brothers to see *Superman III* at the Yeovil Odeon (or Cannon as it was then). I remember the old Automatickets, the cashier with the blue plasters always on her fingers, the transvestite usher ... I remember going with my brothers, my friends and on early dates. And for a guilty pleasure, I'd go on my own – I was scared witless watching a matinee of *Se7en* in an almost deserted Screen One when I should have been at college.

This book celebrates all seven of Yeovil's cinemas, past and present. I hope it inspires your own cinematic memories, whether in Yeovil or elsewhere.

Picture Credits

Assembly Rooms I

The movies arrived in Yeovil in 1896 when the Princes Street Constitutional Club began showing one-reel films as a novelty in its grand Assembly Rooms. The Constitutional Club opened in 1889 and indulged members with reading, billiard and card rooms, plus a bowling saloon, alongside the large Assembly Rooms (65 feet by 40 feet). In the early days of the club, UK entertainment venues only needed one licence to perform theatre or music, and this also covered cinematographs, which were considered such a fad that they didn't justify their own licence. If you compare Leslie Brooks' drawing of the venue in 1900 with this photograph from 2012, little has changed apart from the lower levels now being used as shops and the upper floors as offices. Sadly, no traces remain of the past life of the building as the town's central entertainment destination. (Drawing by Leslie Brook, reprinted by kind permission of David Brook)

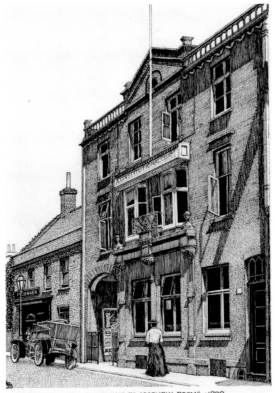

CONSTITUTIONAL CLUB AND ENTRANCE TO ASSEMBLY ROOMS, c1900.

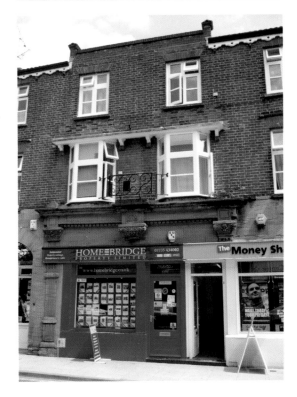

Assembly Rooms II

In January 1910, after the 1909 Cinematograph Act came into force. Film-going had taken off so fast in the preceding thirteen years that all manner of unlikely venues around the country were being adapted into makeshift cinemas. It was time for the authorities to rein things in, not least because the highly flammable nitrate film stocks meant that makeshift cinemas were prone to fires. One consequence of the Act was to demand that cinema buildings had a separate and fireproof projection room to protect audiences. Often, the simplest way to get around this requirement was for proprietors to construct a new venue. The Constitutional Club in Yeovil resisted this option because it had already spent a substantial sum of money updating the successful venue in 1895. At that time, the Assembly Rooms were altered to include a permanent stage behind the proscenium arch, plus three dressing rooms. These alterations meant the hall now seated 700 people instead of the 1,000 people it had previously accommodated. But while the club didn't make drastic alterations to accommodate the Act, it was obliged to apply to the Brewster Sessions for a cinematograph licence. Issued in February 1911, this was the first cinematograph licence in Yeovil.

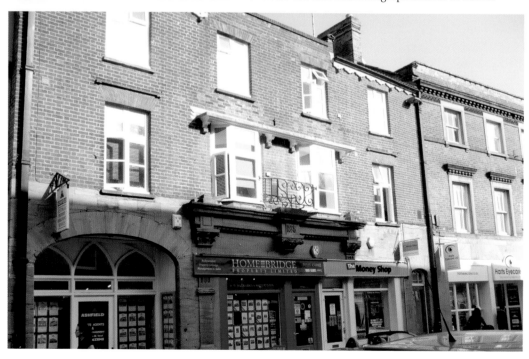

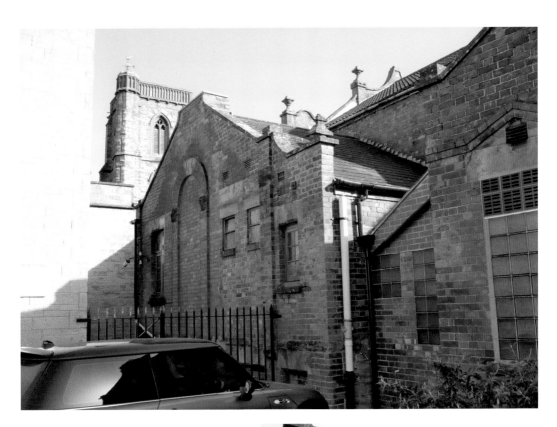

Assembly Rooms III

During the First World War, entertainment venues struggled because many staff were called up for service, but the Assembly Rooms continued to show films. However, by this time, Albany Ward's Palace of Varieties was in full swing on the other side of Yeovil, and the Central Cinema was just around the corner from the Assembly Rooms. Competition was heating up. No more information is available about films being shown at the Assembly Rooms after the war ended in 1918, and the Princes Street Constitutional Club went into liquidation on 6 January 1939. The theatre was still operating in 1965 but under the name of the Princes Theatre. It continued to run until at least 1974, when the newly built Johnson Hall on Hendford (now the Octagon Theatre) was opened and took over as Yeovil's main theatre.

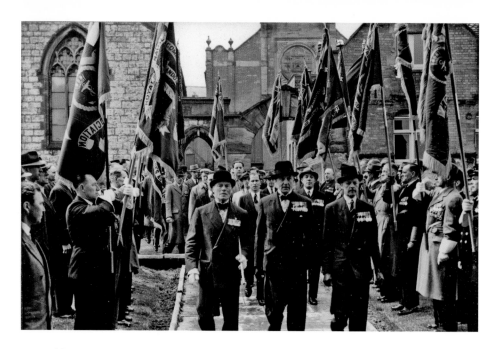

Assembly Rooms IV

If you walk around the back of the former Assembly Rooms, through different alleyways on both Princes Street and Church Street, you can see the body of the former Victorian music hall with many original features still intact (such as lamps, window frames and railings), as well as the roof decorations. The blue disc on the top, encased by stone embellishments, originally housed a decorated stone circle, which can be seen in the picture here (taken in the 1950s). It shows members of the Yeovil branch of the Royal Naval Association taking part in a parade towards St John's church. (Photograph above from the Bob Denmead collection, used by kind permission of the Yeovil Community Heritage Association)

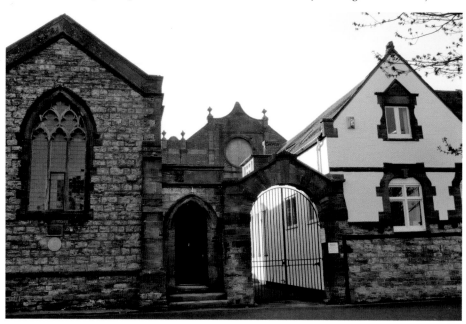

Central Cinema I

The Central Auction Rooms on Church Street, which first showed films in 1912, renamed itself Yeovil's Cosy Corner in 1915. By the following year, the Cosy was so committed to films that it was rebranded the Central Hall Cinema by manager Alfred Sugden. After the First World War erupted in 1914, the new proprietors of the Central Hall Cinema were Messrs A. Little and L. W. Cochran, with Mr Cochran also acting as manager. Under his rule in 1922 the Central showed one film a night, with three screenings on Saturdays and two changes to the programme each week. Depending on whether you sat on the wooden benches at the front or the comfier seats further back, you would spend between 5*d* and 1*s* 3*d* on your trip to the Central Hall Cinema. (Photograph above by Nigel Potts, reproduced by permission, of the Heritage Team, South Somerset District Council; photograph below by Rob Baker, 1988)

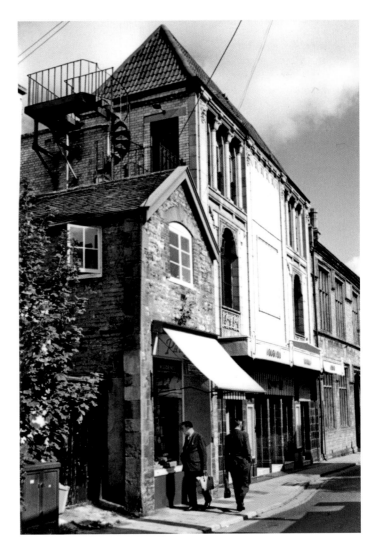

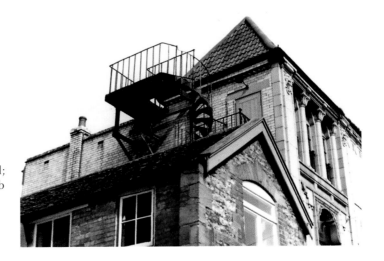

Central Cinema II

In the early days of the Central Hall Cinema, the silent films were accompanied by pianist Percy Collard. His nephew Tony Robins remembers, 'Percy would play piano for the silent movies to match what was happening in the films. He was born in 1904 and was a brilliant pianist, but he was made redundant when the talkies came in. The Central was a bit rough; it wasn't the sort of cinema where you'd take your girlfriend. We called it a fleapit as the seats were tatty, but it was cheaper than going to the Odeon or Gaumont.'

The Central was sold to Archie Thring in 1925, and he employed Mr F. R. Maidment as manager. Their staff included Mr Young as projectionist, and his wife as cashier. Mr Thring ran the cinema on similar grounds to Mr Cochran, but with one difference: the Central now showed films twice a night, with a Saturday matinee.

In the early hours of 24 May 1930 a devastating fire broke out in the Central Cinema. The nearby Assembly Rooms had been holding an Empire Day celebration dance, and when a patron stepped outside for some fresh air he saw flames pouring from the Central. He raised the alarm and, together with Police Constable Udall, broke into the burning cinema to rescue the semi-conscious owner from his office. Volunteers from the Yeovil Fire Brigade laid four lines of hoses through Church Street, and firemen at street level dodged falling slate tiles from the cinema's roof. Firemen inside the building were also at risk from the fumes and dense smoke pluming from the burning upholstery. The strong wind that night didn't help either.

After four hours, the fire was controlled, leaving much of the Central Cinema a wreck. Mr Thring made a full recovery, despite extensive burns to his hands, but sadly, the cinema was not so lucky. Nor were the neighbouring buildings belonging to St John's school, where a quarter of the roof was destroyed and two teaching rooms were water damaged.

However, the *Western Gazette* reported, 'The projecting box had escaped, and an electric gramophone, recently installed at a cost of £200, was unharmed.' Flames had destroyed the partition doors into the cinema auditorium, heat had scorched the walls of the auditorium, and the cinema seats were completely destroyed after blazing rafters fell on to them.

The devastating fire also meant that many regular cinema-goers never did find out what happened in the serial *Scarface* that the Central had been showing – this *Scarface* being a 1932 Howard Hughes vehicle, not the 1983 film starring Al Pacino!

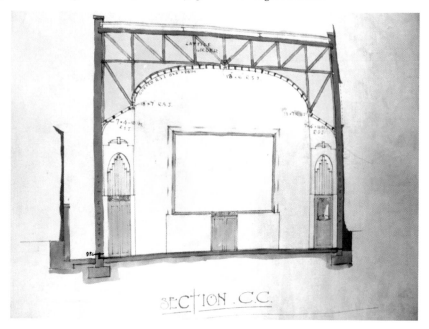

SECTION . C.C.

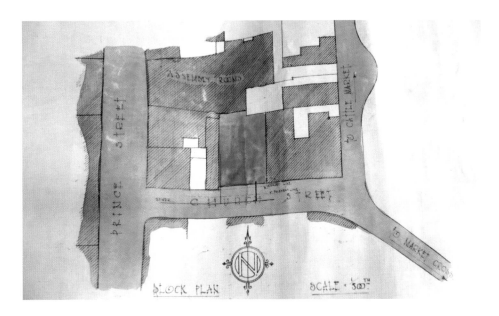

Central Cinema III

The rebuilt Central Cinema opened its new doors in January 1932. Designed by Douglas E. Langford (from Lucas & Langford Architectural Surveyors, based at Guildhall Chambers, Exeter), the new cinema claimed to be 'the last word in comfort in an attractive oriental setting'. Langford's design (parts of his drawings are reproduced here) included an elaborate Art Deco exterior embellished with a faience tile façade, as well as an intricate exterior spiral staircase made of wrought iron. This staircase was the only route for the projectionist to access the projection room. Writing to the *Yeovil Mail* in the 1970s Mrs E. M. Ricketts said: 'My late husband was a carpenter and joiner, and commenced work at the Central on 24 August 1931, and continued until completion at the end of the year. He was even working on Boxing Day and missed his cousin's wedding.'

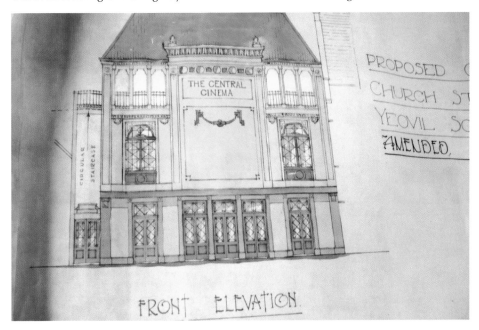

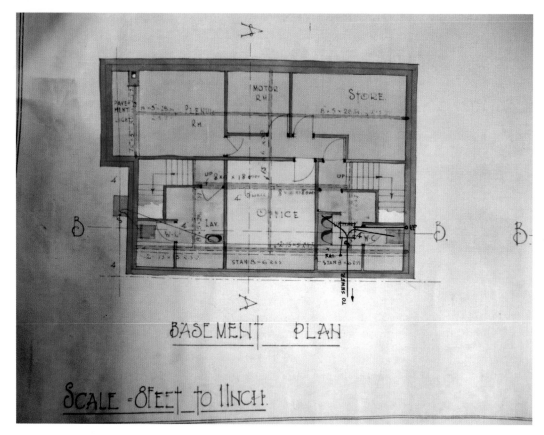

BASEMENT PLAN

SCALE = 8 FEET to 1 INCH.

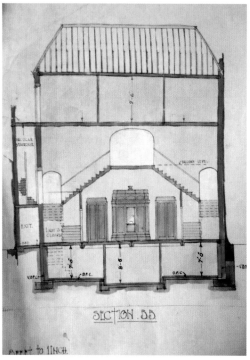

SECTION BB

Central Cinema IV

The *Western Gazette* reported: '[This is] yet another example of the enterprise and development that has given the town such a rapid modern trend. The striking appearance of the new building, which is in the Persian style, vies with the comfort and elegance of the interior.' The lighting installed at the Central gave a sixty-colour change through a mass of coloured lights, and the ventilation system refreshed the air three times an hour, with cooling air during hot weather. An up-to-date Western Electric sound system was installed so that patrons could enjoy the talkies, and films were projected using a state of the art Kalee projector. Mr Thring returned as manager and gave the new Central the slogan: 'Talkies as they should Talk'. Cinema prices remained low until the late 1930s when Mr Thring raised them to between 6d and 1s 6d. At this time he also took on his nephew, Mr S. T. Thring, making the Central the only family-run cinema in Yeovil.

Central Cinema V

By May 1937, the same month that the Odeon opened in Yeovil just a few minutes away, Mr S. T. Thring had become the Central's proprietor with Mr T. F. Hough as resident manager. The cinema was so up-to-date that it even had a phone installed (Yeovil 567)! Pictures showing that week included *Piccadilly Jim* (a 1936 romantic comedy), *The Man Behind the Mask* (a 1936 drama), *Love up the Pole* (a 1936 comedy), *Underneath the Arches* (a 1937 comedy), and *Spy of Napoleon* (a 1936 historical drama). However, the outbreak of the Second World War in 1939 meant that all buildings of entertainment in the UK were closed for two weeks, and were only allowed to reopen with the proviso that they adhered to the nationwide blackout. That didn't stop patrons from wanting a film fix, as Barbara Williams said in the *Yeovil Mail* in the 1970s: 'During the war, I remember queuing three nights running before I could get into the Central to see *Gone with the Wind*. I have many happy memories of the old Central.' (Drawing by Leslie Brook, reprinted by kind permission of David Brook; photograph by Rob Baker, 1988)

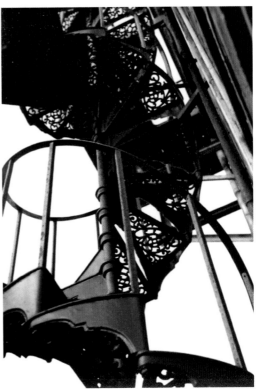

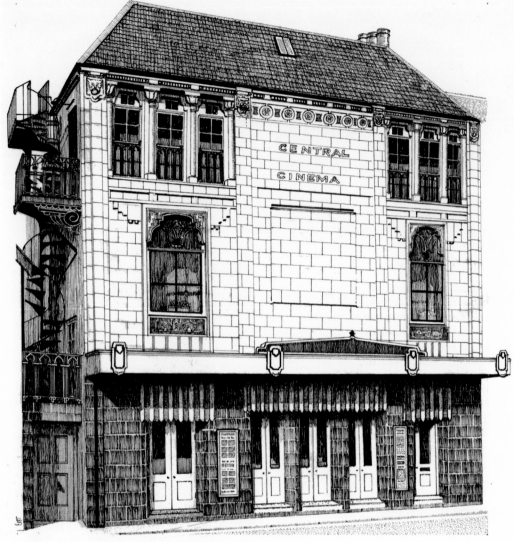

CENTRAL CINEMA, CHURCH STREET.

Central Cinema VI

Throughout its subsequent thirty-two-year run as a cinema, the Central remained independent from all of the cinema chains and was known for largely showing films that the main cinemas would not. However, competition for audiences was growing. From the 1930s, Yeovil had two enormous super-cinemas (the Gaumont, which opened in 1934, and the nearby Odeon, which opened in 1937): both of these temples of entertainment and luxury made the cosy and quirky Central seem like a tired old relic ... or a fleapit. (Drawing by Leslie Brook, reprinted by kind permission of David Brook)

Central Cinema VII

'Fleapit' was the term by which the very first purpose-built cinemas were known after the proliferation of super-cinemas in the 1930s. If the original cinemas were not remodelled to reflect the changing times, fickle audiences tended to gravitate towards the grander and more modern picture palaces, which also won the better films from the distribution companies. As a result, the abandoned smaller cinemas became little more than dusty old ... well, fleapits. By 1945 film screenings at the Central had become continuous after 2.10 p.m. every day and prices had risen to between 9d and 1s 10d. (Photograph above courtesy of Cinema Theatre Association Archive; photograph below by Rob Baker, 1988)

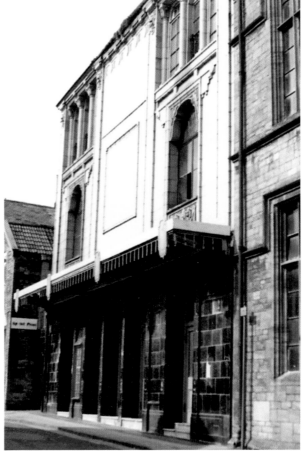

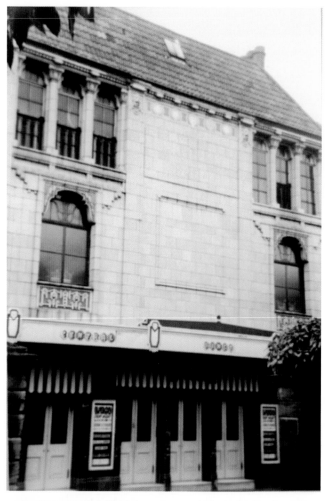

Central Cinema VIII

A second fire broke out at the cinema on 25 May 1950, putting the building out of action for more than a year until its final reopening in November 1951, with both a fancy new lighting system and the 1931 silent film *City Lights* by Charlie Chaplin. A twenty-year-old silent film seems an absolutely bizarre choice for an opening night when the cinema was struggling to appear modern and was desperate to compete with its high-tech contemporaries. Also included on this page is a scan of a Walls ice cream advertising slide that was found in the disused Central shortly before it was demolished. It is likely this was one of several static adverts projected onto the screen before the main feature began. (Photograph above courtesy of Cinema Theatre Association Archive; scan of advert below by Rob Baker)

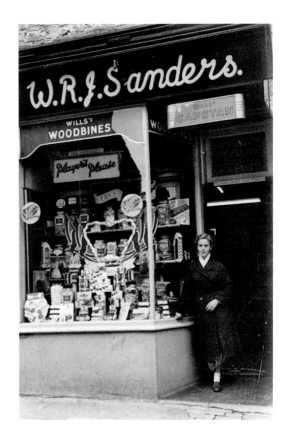

Central Cinema IX

Jack Sweet remembers going to the Central in the 1950s when he was on leave from the RAF. 'They had some jolly good films,' he says. 'I particularly remember the Bill Haley musical *Rock Around the Clock* in 1956, which was really something. It was an independent cinema, so they could choose their own films. The Central was a very dingy and dark place, though, compared with the Odeon and Gaumont, which were massive entertainment centres.'

The post-war economic slump was finally easing in the 1950s, and the British public suddenly found themselves earning more money. Along with greater incomes came a new-found ability to buy better quality items on hire purchase ... and among these items were televisions: the gadget that brought the cinema experience into your home. Before the 1950s, there was no television in Yeovil – the signal wasn't switched on in the town until 1952.

After rising from the ashes of two major fires, the Central was still not given a break and the popularity of television by the mid-1950s meant that cinema attendance everywhere was dwindling. Desperate to turn their fortunes around, cinemas needed to come up with something new to tempt patrons in and the answer was believed to be CinemaScope, the forerunner of what we now know as widescreen. The Central bought into CinemaScope (which only lasted nationally from 1953 until 1967) and erected a 24 feet by 10 feet screen in its 27-feet-wide proscenium with which to show CinemaScope epics.

Around this time, the Central's resident cat also became a charming extra feature in the cinema's offering, and would prowl around the auditorium while movies played, sometimes making itself at home on the laps of an unwitting audience member. Many people also remember the sweetshop next door to the cinema, run by Trevor Parry and pictured here, which would stay open until 8 p.m. every night in order to catch the passing cinema trade. The shop was demolished with the cinema in 1988. But none of this was enough to keep the Central in business, and on 8 August 1964 it closed as a cinema for good, with a final screening of the 1963 Disney musical *Summer Magic*, starring Hayley Mills.

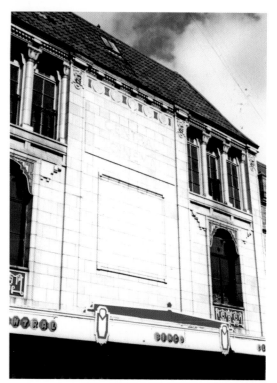

Central Cinema X

The Central, which was owned at this time by Harry Thorne, subsequently became a Boscombe bingo hall until 1979, when the unlisted building was threatened with demolition. However, in February 1979, the *Western Gazette* reported that the Manpower Services Commission was keen to build a Jobcentre on the site, in acknowledgement of the fact that Yeovil was the only sizeable town in the South West without one at that time. Other proposed ideas for its use included a nightclub or a private members' club – an idea put forward by at least two groups. By the time the wrecking ball came, there were less than five similar cinemas in the entire country, none of which were in the South West. (Photographs by Nigel Potts, reproduced by kind permission of the Heritage Team, South Somerset District Council; scan of bingo card by Rob Baker)

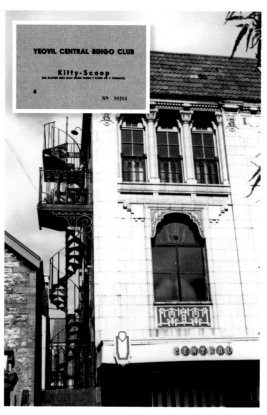

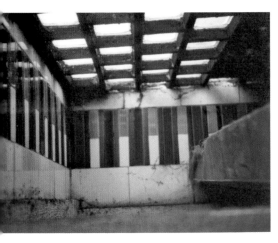 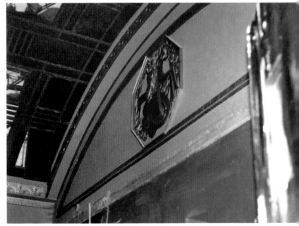

Central Cinema XI

The cinema escaped demolition in 1979, although it was gutted internally and remained empty for much of the next decade, except for use as (horror of horrors!) a car park. The Department of the Environment turned down a request to have the building listed, claiming it was not worthy of such status. Dennis Berryman, who was Assistant Planning Officer in Yeovil, insisted the façade was the only one of its kind outside London, but the building remained unlisted. Despite further protest, the Central was razed in 1988 – depriving the UK of a valuable piece of architecture. (Photograph above left by Nigel Potts, reproduced by kind permission of the Heritage Team, South Somerset District Council; remaining photographs by Rob Baker, 1988)

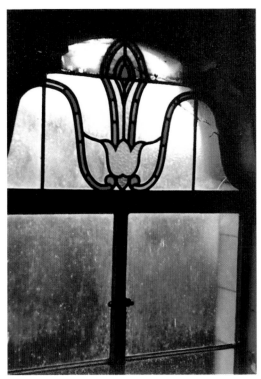 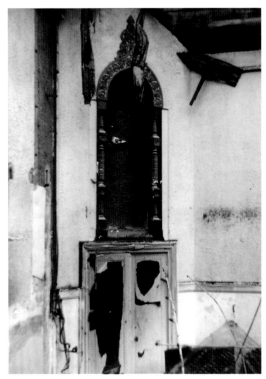

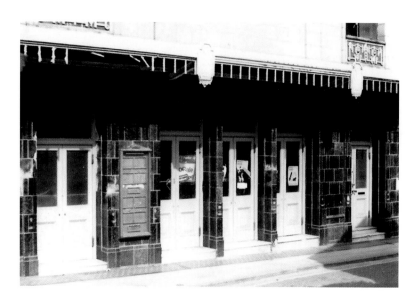

Central Cinema XII

On demolition day in 1988 Rob Baker took these pictures. The first shows the building, long abandoned and with an optimistic 'for sale' sign tucked inside the front door. The second shows the building deserted after it was half-demolished. This is a particularly sad photograph, offering a glimpse inside the top of the dejected picture palace. It is unlikely Yeovil, or anywhere, will ever see such a detailed and opulent movie theatre again, and it was an absolute travesty that it was allowed to be destroyed. (Photographs by Rob Baker, 1988)

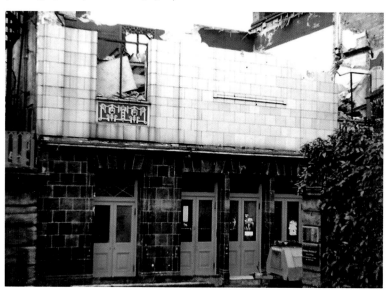

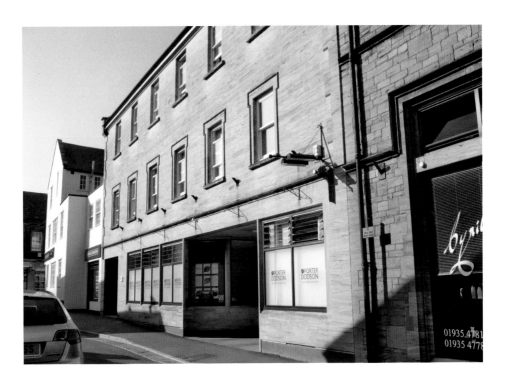

Central Cinema XIII

A bland-looking solicitor's office now stands on the site and no-one would have any idea that a beautiful Art Deco picture palace, with an ornate spiral staircase and intricate red and green paintwork, once stood in the place of this anonymous office block. The only hint that anyone gave a passing thought to the site's former life is the name of the current building: Central House.

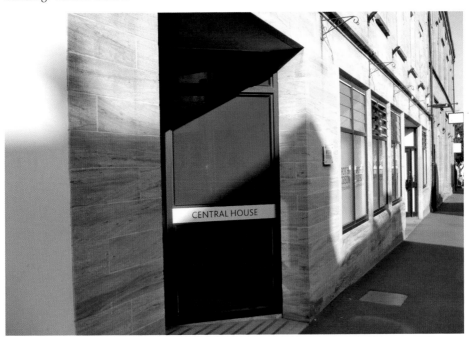

Albany Ward I

Albany Ward was born in London on 6 November 1879, as Hannam Bonnor. On a holiday to North Devon in 1893, Bonnor met the American moving-image pioneer Birt Acres, who later gave him his first job in film in 1896.

With Acres, Bonnor enjoyed experiences as illustrious as filming Queen Victoria's jubilee procession in 1897. But Bonnor felt Acres was not 'sufficiently progressive' and that the film-maker was sitting back while others were stepping on the toes of his business. So Bonnor – not even eighteen – did just that, and left Acres in 1897 to work as a lanternist (also known as a projectionist) with the Velograph Syndicate Company, screening films in music halls.

Bonnor bought his own Velograph projector in late 1898, and toured as a lanternist in music halls under his newly adopted professional name, Albany Ward. The change of name was on account of his mother worrying about the good name of Bonnor being linked to the disreputable cinema and music hall trades.

Between 1897 and 1901 Ward toured the parts of the country that were normally excluded by lanternists. Travelling on the train between London and Ilfracombe meant he became acquainted with the many towns along the route: the railway system was far more complex then, and incorporated smaller towns that have long since been bypassed.

Ward would plan his programmes – which were, naturally, of silent films – to include films that would necessitate a loud response in his audience, in order to generate sound effects. In his memoirs Albany Ward wrote of one programme: 'From the very commencement of my own shows, I introduced sound effects with all principal films and found this a great success. I had a film of a railway ride with a train passing through many cuttings and several tunnels. This gave great scope for effects and invariably brought the house down. Battle scenes, the Greco-Turkish war, Battle of Omdurman etc., also gave good scope for sound effects, as did also Birt Acres' rough sea pictures, particularly with waves breaking right up to the camera and seeming to come into the audience, which created shrieks and real alarm in some cases.'

Six years after setting up Albany Ward's Entertainment Business, the entrepreneur launched the first cinema bearing his name, Albany Ward's Imperial Electric Pictures, which opened in Weymouth on 1 February 1909. The Albany Ward circuit grew rapidly across Wiltshire, Dorset and Somerset, and spread to Jersey and Guernsey. What separated Ward from his competitors was that he focused on small towns where there was less competition and property was cheaper.

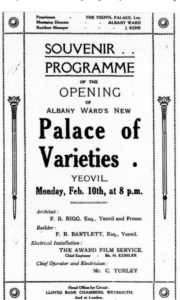

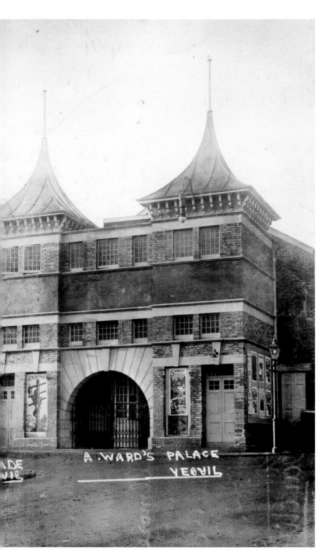

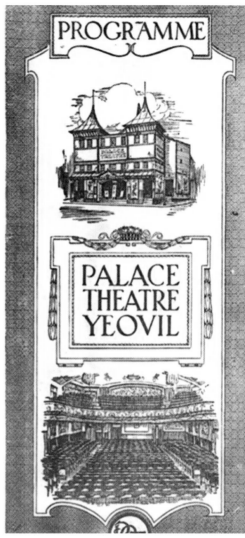

Albany Ward II

At a meeting on 8 July 1912, Yeovil Borough Council approved plans for the picture palace on The Triangle, and a theatre licence was granted to the town's first purpose-built cinema in February 1913. The *Western Gazette* of 14 February 1913 wrote: 'On Monday evening, the new picture theatre, which has been erected in The Triangle for the Yeovil Picture Palace Ltd, was opened, and the smart little house was crowded with an audience that included a large number of the leading residents, members of the governing body, and officials of the Borough ... The programme presented – both pictures and variety – was an excellent one, and met with entire approval. Mr Albany Ward, the managing director, in the course of a speech outlined the reasons that had led to the building of the theatre. He complimented the architect, Mr F. B. Rigg of Frome, and the builder, Mr F. R. Barlett, of Yeovil, on the success of their work, and thanked the Mayor and Corporation, the Borough Magistrates, Mr Oddy, the Borough Surveyor, and other officials, for the courtesy and consideration shown them during the time of building. Altogether the opening was entirely satisfactory and if the standard of entertainment was kept up to that then given it augurs well for the success of the venture.' (Photograph courtesy of Cinema Theatre Association Archive; scan by Rob Baker)

On opening night, the New Palace offered a true variety performance, starting with six short films and followed by four pieces of vaudeville theatre. After a live overture conducted by C. V. Fentiman, the programme launched into the films, which were *Luxembourg Gardens* ('a pretty scenic study'); *Those Lovesick Cowboys* (a 1912 western comedy); *Jack and the Beanstalk* ('a splendid pantomime'); *Bunny's Suicide* (a 1912 comedy directed by Laurence Trimble); *The Badminton Hunt* (for which no description was offered); and *The Count of Monte Cristo* (a 1912 feature directed by Colin Campbell).

'The building throughout is designed according to the latest and most approved modern ideas,' began the souvenir programme for the opening night, before filling its readers' heads with paranoia about the flammability of any other cinema they might visit. 'The theatre is of fireproof construction and all stairs, entrances and exits are entirely fireproof. The auditorium on the ground floor is provided with seven wide exits, all doors opening outwards. Each door being fitted with patent panic bolts. The balcony is provided with two separate entrances and exits, each leading to a separate fireproof staircase. Both in the balcony and ground floor convenient cloakroom and lavatory accommodation for ladies and gentlemen is provided. The operating chamber, of very spacious dimensions, is situated outside the auditorium and is entirely fireproof.'

The programme continued: 'The building is warmed throughout with the latest hot water system. Ample ventilation is provided. Numerous fresh air inlets are installed and two powerful 36-inch extractor fans, driven by powerful electric motors, remove all vitiated atmosphere. The seating throughout the whole building, with the exception of the front seats, is 'tip-up', and in the balcony each seat is numbered and reserved. A large stage has been provided of ample dimensions to accommodate the largest touring dramatic attractions, and is in every way equipped with latest appliances. A fireproof curtain is fitted, which will be lowered once nightly to ensure its safe working. The latest electric devices in lighting etc. are provided. Ample dressing accommodation has also been provided. The building is lighted throughout with electric light, and a complete electric plant is installed, the current being generated by a 20 hp engine and dynamo, the output being 150 amperes at 65 volts. Gas lighting is also provided in case of emergency. The operating box is fitted on the latest and move approved form and comprises the latest Kinemacolour machine, driven by half-horse motor.'

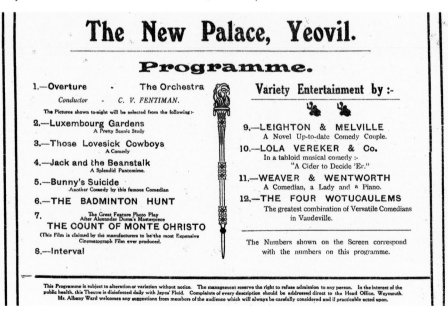

26

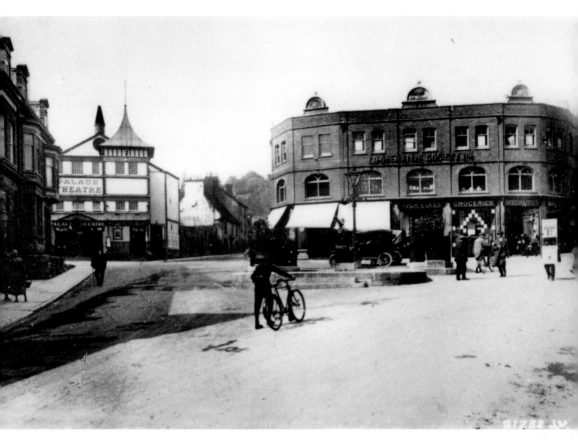

Albany Ward IV

The Palace ran performances nightly at 8 p.m., with three screenings on Saturdays at 3 p.m., 7 p.m. and 9 p.m. Prices ranged between 3*d* and 1*s* 6*d*, with an early-doors policy from 4*d* to 1*s* 9*d*. If you wanted to book a seat, you could do so by contacting Mr Whitby at the town library. The Palace's first manager was Jack Kerr, but as was common in most cinemas at the time, there was a regular change in management. This makes it difficult to chart everyone who took charge of the cinema, but Mr H. St Clair managed the theatre until his death in 1918, succeeded by Mr J. Shaw until 1922, and then Philip E. Davy, who oversaw the Palace until it closed in 1929. By 1914 Ward had twenty-nine cinemas (with 14,000 seats in total) in his circuit. This was the largest chain in the South West and as a result Albany Ward became a brand name that people could trust. Cinema attendance was enormous and many people would go to the pictures twice a week, which prompted cinemas to start changing their bill midway through the week. (Photograph reproduced by kind permission of the Heritage Team, South Somerset District Council)

Albany Ward V

Along with much of England and Wales, Yeovil was struck by Spanish Flu in 1918, and eighty-one deaths were recorded in the town. The first reported case was in early July 1918 in Pen Mill, and it was thought the virus had passed by the middle of August. However, it returned in October with a vengeance. Originating again in Pen Mill, where it was probably brought in by the railway workers, the virus spread across Yeovil. Sadly, Mr H. St Clair, the manager of the Albany Ward Picture Palace, was one of the eighty-one fatalities. The virus reached its height in November and left Yeovil for good by Christmas.

Ward went out of business in 1919, and an Extraordinary General Meeting was held on 10 January 1921, in Bristol, to discuss the fate of his chain. It was resolved that the business would be liquidated and wound up. From this time, the cinema was run by the Provincial Cinematograph Theatres, and the Yeovil branch was renamed the Yeovil Palace Theatre. (Photograph reproduced by kind permission of the Heritage Team, South Somerset District Council)

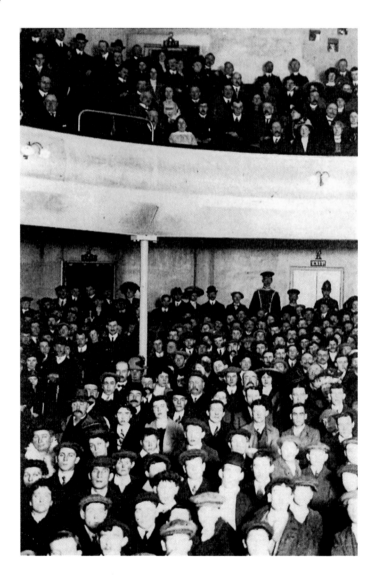

Albany Ward VI

On Tuesday 11 August 1926, a vision of Hollywood stepped into Yeovil in the shape of silent movie star Betty Balfour. The London-born actress was a leading figure in British silent movies, and was acclaimed as the only British star on the international scene. Dubbed the 'Queen of Happiness', Betty made a public appearance at the Yeovil Palace Theatre to promote her film *Squibs Wins the Calcutta Sweep*. The streets around The Triangle were packed with fans who watched Mayor Alderman Jabez Matthews welcome the actress while the town band played 'Rule Britannia'. After the film, Betty was the guest of honour at a party held at the town's Mermaid Hotel on the High Street. Only two years later, Betty starred in the Alfred Hitchcock film *Champagne*. As the photograph shows, the Palace Theatre was showing two films in 1927. One was *White Pants Willie* (a 1927 comedy: 'He knew clothes made the man, but he had no idea breezy flannels would make him a ladies' man'). The second was another American comedy, *A Gentleman of Paris* (starring Adolphe Menjou and Shirley O'Hara, 1927). The Provincial Cinematograph Theatres circuit was taken over by Gaumont in February 1929, and the company demolished Albany Ward's building in 1933. (Photograph above reproduced by kind permission of the Heritage Team, South Somerset District Council)

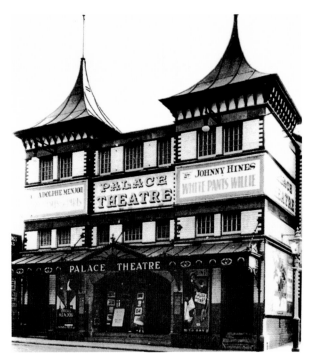

ALBANY WARD THEAT

YEOVIL AMUSEM

THE PAL

THEATRE Nightl

SATURDAY 2.30. 6.

Star Varieties. ∴ Super Film Plays.

No. 1 THEATRICAL COMPANIES.

NEAL & WILLIAMS,

J. J. MINTY, Proprietor,

Furnishing Ironmonger,

YEOVIL.

The Best House for all kinds of Tools, Cutlery, Suit Cases and Travelling Requisites.

The Globe I

The British Armed Forces have been using cinema to entertain troops in their camps for a long time. Initially, military cinemas were run by outside businesses but gradually they became self-sufficient enterprises run by either the Army Kinema Corporation or the RAF Cinema Corporation. The Navy also ran a smaller cinema operation. Many of these cinemas operated full-time, with a dedicated building on each camp and service personnel who were trained to do everything from running the projector to booking the film programmes. New films were distributed on Mondays and Thursdays. Many of the buildings had been specifically designed as cinemas, and these were typically spaces that could seat about 200 people. The Army Kinema Corporation even had its own fleet of service vehicles, which were painted dark olive green and had the words 'The Army Kinema Corporation' emblazoned on the sides.

The Entertainments National Service Association was set up in 1939 by the English film directors Basil Dean and Leslie Henson to entertain British servicemen during the Second World War, whether by theatre, song or film. It had a reputation for providing terrible entertainment, though, and the standing joke was that the initials ENSA stood for 'Every Night Something Awful'. During the Second World War, ENSA was under the umbrella of the War Office, and most senior staff were ex-personnel with officer status. The RAF's independent cinema organisation was called Astra, and had twelve cinemas throughout the British Army of the Rhine. The Services Sound & Vision Corporation appeared in 1982 after the other corporations were merged.

The Association was part of the Navy, Army & Air Force Institutes, and continues to operate in 2012 as part of the Services Sound & Vision Corporation, which was formed in 1982 after merging the Army Kinema Corporation and RAF Cinema Corporation. Currently, the Services Sound & Vision Corporation circuit has just nineteen cinemas, of which only six are in the UK and Northern Ireland.

The study of British Armed Forces' cinemas is neglected in the UK, although research is now being undertaken to rectify this. The locations of the forces' cinemas were often fairly rural, which may explain why they are frequently excluded from local cinema histories. During the 1950s, forces' cinemas became private, meaning they no longer required licensing. This also meant that they fell under the radar for listings in the Kinematograph Yearbook or local authority records, and in subsequent years the Services Sound & Vision Corporation lost all of its archives, meaning there is no longer a single resource with all the information.

Every effort was made to uncover original photographs for this section of this book, but for the reasons just mentioned they were unfortunately not to be found.

The Globe II

For some reason, the majority of the Army Kinema Corporation cinemas were called the Globe, and the cinema at the Houndstone army camp on what is now Boundary Road in Yeovil (but was then the Country Road) was no different. The camp dated back to 1925 when the buildings had nothing more than canvas roofs, and it is believed the Globe Cinema opened on the camp in the early 1930s.

During military occupation, one side of the camp was a vehicle driving instruction camp, and the other was a maintenance training depot. (Reproduced by kind permission of the Heritage Team, South Somerset District Council)

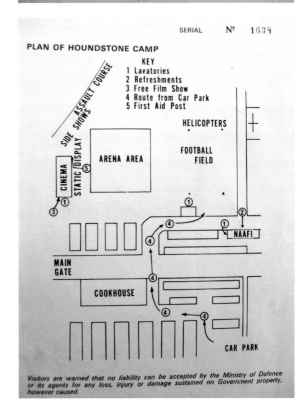

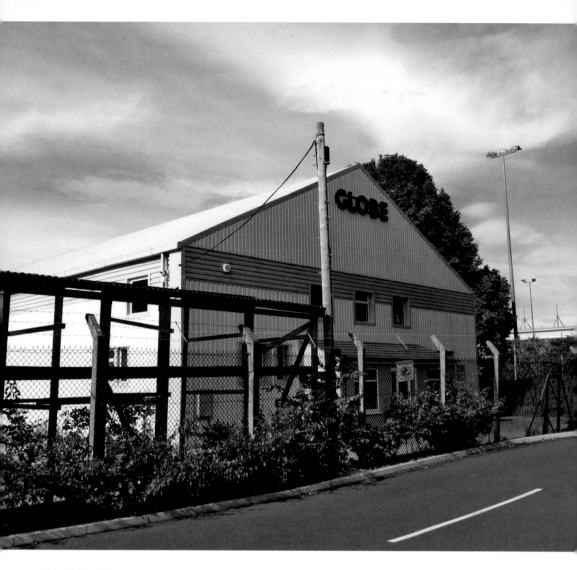

The Globe III

The cinema was extremely popular with service people because, at only *6d*, it was far cheaper than the cinemas in Yeovil town centre. A different film would be shown each night, except on Saturdays and Mondays. And the programme would begin with a newsreel, followed by the main feature, and then a *Tom and Jerry* cartoon. It was apparently always extremely noisy in the cinema! Reportedly, the building had a main auditorium, office space upstairs, and two mezzanine floors, as well as an external lean-to shed. The corrugated-iron roof meant that when it rained, audiences struggled to hear the sound from the films! The photograph here shows the replacement Globe building, captured in 2012.

The Globe IV

William Hawksford arrived at the facing camps of Houndstone and Lufton in January 1947 to start his service with the Royal Army Service Corps as a driver mechanic. In his online memoirs, Hawksford lists the amenities at the camp as including 'a cinema, a dance hall, a gymnasium, administration offices and a NAAFI [Navy, Army & Air Force Institute]'. He describes the buildings as generally being in a bad state of repair by the late 1940s.

He writes: 'Attending the cinema called the Globe at Houndstone camp was a memorable experience. The old wooden structure was filled to capacity with soldiers and ATS [Auxiliary Territorial Service] girls, who came to see a film about American gangsters, featuring Cornel Wilde [possibly *The Walls of Jericho*]. Everyone was enjoying the Hollywood entertainment until Mr Wilde, who was playing the part of a detective, made a remark that hit a funny bone and at that juncture the audience went into convulsions. Pandemonium broke out and, to put it in the vernacular, "they went bonkers". This adolescent behaviour continued for the rest of the picture, making it impossible to hear another spoken word.'

Another serviceman, John Orr, was posted to the Houndstone camp in 1964, where he completed his driver training. Writing on an online Forces Reunited forum in August 2007 he said: 'I remember the YMCA [Young Men's Christian Association] canteen outside the barracks on the WRAC [Women's Royal Army Corps] side of the road, going to the cinema in the camp and getting drunk on scrumpy. Good memories.'

Around 12,000 American troops were based in Yeovil in the build-up to D-Day in June 1944, many of them stationed at Houndstone Army Camp. Dave Cousins was too young to serve at Houndstone, but growing up in Yeovil he remembers the camp and the Globe Cinema from a child's perspective. Writing on another ex-serviceman's forum in September 2010, Cousins said: 'There were American and British troops billeted all over [Yeovil]. They … put on a party in the cinema at the Houndstone camp for school children before they [the troops] went to Normandy. The children were chosen by ballot and I was then at the Huish Junior School, and was lucky enough to be drawn out of the hat to go to the party. That was when I tasted my first orange and banana since the start of the war.'

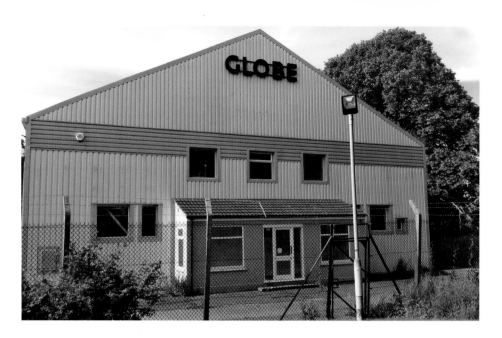

The Globe V

The projectionist at the Globe in 1953 was fifteen-year-old Clive Wilkins. It was a job he held for two years: 'My time at the Globe was the happiest and most rewarding of all my places of employment.'

During Clive's time at the Globe, the full-time staff comprised manager Mr Jones, chief projectionist Mr K. Garrett and himself. They were supported by a part-time projectionist, a cashier, two ushers, an ice cream seller and a cleaner.

Clive says: 'The cinema was a large cream-painted building at the end of a tree-lined *cul-de-sac*. On the front were five illuminated poster frames. Seating was in six blocks, with one aisle in the centre and two more aisles at each side, with three cross aisles. To stand up to the wear of the army boots, lengths of dark brown coconut matting was laid in the aisles. The cinema was a wide building with a low ceiling, which made it ideal for the shape of a CinemaScope screen. The proscenium arch and stage were rebuilt further forward and widened to accommodate the three banks of speakers on the left, centre and right of the stage.'

Clive remembers how a typical day at the Globe would pan out. '8–10 a.m.: I came in through the fridge room, and let in four army personnel through the Globe's front door. Two of them would sweep the floors and empty ashtrays, and the other two would roll up the coconut matting and sweep the polished red floor underneath. On a Friday, I'd cycle around the camp putting up posters.

10 a.m.–12 p.m.: A quick NAAFI break. Back at work, we'd make up the feature for the next day and the trailers to be shown that night. After that, we'd do general maintenance.

6.45 p.m.: Entering the building at night, we'd go on stage to switch on the house lights. In the box, we'd switch on rectifiers and amplifiers, select records (from the personal collections of me and the ushers) and load the autochanger.

7–7.30 p.m.: Doors opened, and we played music by the likes of Elvis Presley, Tommy Steele, Billy Haley & His Comets, before the National Anthem, for which everyone would stand.

7.30–10.30 p.m.: After the supporting programme, there'd be a short interval for ice-creams and drinks, and then trailers for upcoming films – we didn't have a newsreel. And then there'd be the main feature. On the way out, we sold Smith's crisps.'

Clive remembers: 'The town cinemas showed the films first and we had them at a later date. There were not enough troops on camp to fill a cinema the size of the Globe. The largest number of people was when the cinema was used for the Remembrance Day service.'

The Globe VI

Houndstone Camp's illustrious history continued after the war ended as it performed various functions, including acting as a refuge for Asian people who were expelled from Uganda by Idi Amin in 1972. Given just ninety days to leave, many Ugandan Indians opted to come to the UK if they had dual nationality.

Former refugee Vimla Patel spoke to *The Independent* in July 2011 about her exile from Uganda to the former army camp in Houndstone: 'I was married and two months' pregnant with my first child when we came over. It was October and very cold when we arrived. We didn't know where we were going. When we arrived at the airport we were given warm coats by the Red Cross. We ended up in a camp in Yeovil, Somerset. Next day we were called in the office and were given £2.20 benefit and, being literally penniless, we accepted the money but looking at the money in our hands, we felt bad. From a prosperous background, we felt we were being treated as beggars.' After a month at the camp in Yeovil, Vimla and her family moved to Cardiff, where they still live.

Historian Jack Sweet said in 2009: '[Houndstone] was still in operation until around twenty years ago. It was two camps, Houndstone and Lufton, and they both played a very important role in the life of the town for more than forty years. Thousands of troops passed through there and the camps were a good source of local employment and were greatly missed when they closed.'

Between 1993 and 1996 there were battles going on between local business people to take over the former Globe Cinema for uses ranging from a warehouse to a nightclub. *The Yeovil Express* reported on 4 March 1993 that developers had won backing from the Department of the Environment to convert the Globe into a temporary warehouse, despite the failure of previous attempts to turn the disused cinema into a variety of entertainment and recreation venues, leaving the building boarded up and vandalised.

By 26 January 1995, the *Western Gazette* was reporting that parish councillors in nearby Brympton were opposing plans to convert the Globe into a permanent warehouse, claiming it was infringing planning laws, after the Secretary of State had stated several years previously that the land should be kept for recreational use.

On 9 March 1996 the *Western Gazette* relayed South Somerset District Council had granted that the Globe could be used as a permanent warehouse, but on 11 July 1996, they reported that the now empty Globe was earmarked to become a nightclub. The application was later rejected after the Department of the Environment said this would be too noisy for residents.

Today, there is no evidence of the army camps at Houndstone and Lufton: the Houndstone site is now the home of Yeovil Town Football Club's stadium (which opened in 1990), while the Lufton site is occupied by a business park. At the time of writing, a new warehouse stands on the site of the former Globe Cinema, but it retains the name of the Globe, which is presented in the same font.

Gaumont Palace I

Gaumont demolished Albany Ward's building and architect Mr W. E. Trent (who was the chief architect of the Gaumont-British Picture Corporation) designed a super-cinema in its place, assisted by Ernest F. Tulley. The Gaumont Palace opened on 15 December 1934, after building work began in April of that year. It could seat 1,295 people (811 in the stalls and 384 in the circle), and was humbly billed in the programme as 'Yeovil's latest Wonder House of Entertainment'. The *Western Gazette* hailed the building a triumph of modern art, saying: 'The new Palace is one of the most luxurious picture theatres in the provinces.' The pictures here show how the building currently looks in 2012, alongside the 1934 surveyor's report, signed by Trent. (Scan reproduced by kind permission of the Heritage Team, South Somerset District Council)

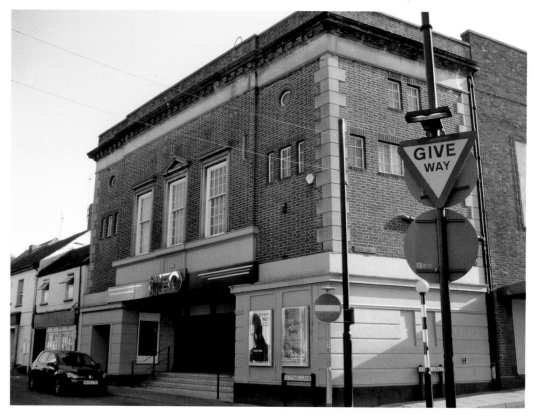

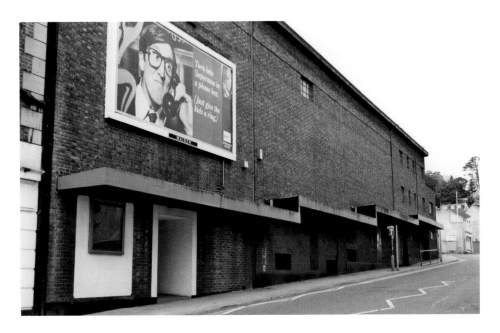

Gaumont Palace II

The Gaumont Palace's restrained frontage was built on Georgian lines with Fareham red brickwork and white stone dressings, sourced from the nearby quarry at Ham Hill. There was a separate entrance for front-stall patrons on South Street, and the façade on this side was faced with Fletton bricks. Covered queuing spaces were provided, and these remain completely untouched today (the photographs on this page show them in 1993 and 2012). On 14 December 1934, the *Western Gazette* called the new 'luxury theatre' 'a triumph of modern art'. (Photograph above by Jack Sweet, 1993, reproduced by kind permission of the Heritage Team, South Somerset District Council)

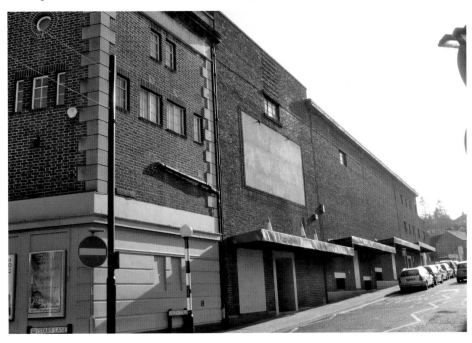

Gaumont Palace III

The cinema featured a 48-foot proscenium and had an overhanging plaster canopy shaped to converge with a backlit, fluted column on each side of the proscenium. These columns ended in elliptical lighting bowls, which housed concealed coloured lamps to illuminate the lighting cove and throw the columns into bold relief.

Seating inside the Art Deco auditorium was on a stadium plan, with 384 on a raised stepped area at the rear, and 811 on the main floor. The walls were covered in tapestry panels of blue and gold, with fluted pilasters separating them.

The opening night programme boasted: 'As befits such a structure, which must find its greatest use at night, a special feature has been made of the front lighting and the Gaumont Palace will henceforth provide a very bright spot in Yeovil after dark.'

Fitted with a British Acoustic Sound (BAC) system, cinema ticket prices started from 1s up to 2s 3d; after the war, they rose from 1s to 3s 6d. There were even concessions made for the hard-of-hearing, and seats fitted with Ardente hearing aids were available at no extra charge. (Photograph above from the Cave Collection, 1965, reproduced by kind permission of the Heritage Team, South Somerset District Council; photograph below by Rob Baker)

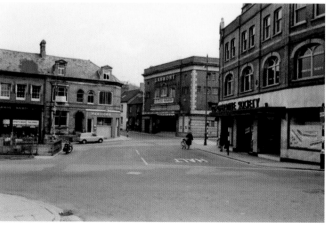

Gaumont Palace IV

The opening night programme guided its readers through the impressive new building. 'Through the wide glazed swing doors of the main entrance at the corner of The Triangle, the patron passes from the street through the teak panelled entrance hall, where the manager's office, telephone and cloakrooms are placed, into the foyer. This apartment, presenting an appearance at once cheerful and inviting, runs practically the whole width of the theatre, and affords a spacious lounge wherein patrons may wait in comfort. Here pay-boxes and chocolate kiosks are available for their service.

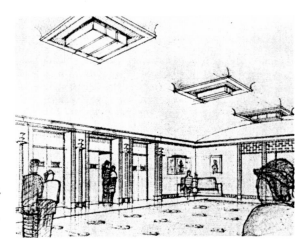

'The plain surface of the walls between the fluted fibrous plaster motifs has been treated with textural paint, and the whole decorated in tones of orange chrome, shaded up from the bottom to tone with the red of the carpet, while the plaster grilles, through which the air is circulated, have been picked out in silver and blue to form a pleasing contrast. The domed ceiling has been treated in lighter shades of the same colour, and the three box fittings suspended from the fibrous plaster plaques are fitted with tinted glass to give a pleasing effect to the illumination.

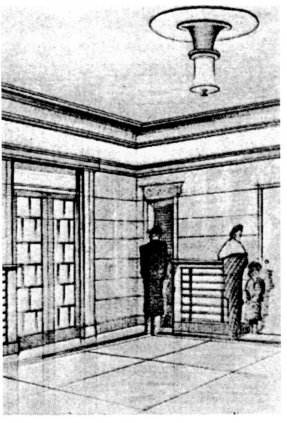

'At each end of the foyer are placed the entrances to the auditorium. Upon entering the auditorium one cannot fail to be struck by the sense of spaciousness which is here presented, for what is known as the stadium type of planning has been employed, the rear portion of the auditorium being arranged in a series of stepped tiers, which form the usual balcony, and which is reached by a short flight of steps from the auditorium itself, thus obviating the necessity for the patron to climb up several flights of stairs to reach the balcony level as is usual in the average theatre or cinema.' These drawings are taken from the programme.

Gaumont Palace V

All of the materials used in the building's construction were British, and much was sourced from local suppliers, such as Bradfords Building Supplies in Yeovil. 'Another gratifying feature is that employment has been given to a considerable number of local men during the whole time that it has been under construction,' noted the programme.

It continued: 'With regard to the decorative scheme, probably the first thing to attract the eye is the novel form of treatment to the very wide proscenium opening, with its shaped overhanging canopy, flanked on each side with a tapering fluted column terminating in an elliptical lighting bowl; concealed in the backs of the columns are a series of coloured lamps which illuminate the lighting cove and thus throw the columns into bold relief. The plain surfaces of the ceiling have been treated in blended shades of pink, green, cream and blue to give a mother-of-pearl effect, and the fibrous plaster motifs and frieze scumbled in tones of beige and certain mouldings relieved in blue and gold. The walls are covered with tapestry of modern design in contrasting shades of blue and gold, with fluted pilasters at intervals to form a connecting link with the dark blue dado. The fabric, in addition to being decorative, ensures perfect sound reproduction.

'The whole design is one of quiet simplicity and restfulness, while the colouring blends a degree of warmth and comfort. The seating is of the most luxurious type, with super-sprung seats and deeply curved backs; ample room is afforded and every seat commands an uninterrupted view of the screen and stage.'

The heart of the theatre, the operating chamber, 'is situated at the back of the balcony, and completely outside the auditorium. From this coin of vantage or conning tower everything connected with the showing of the film is controlled, the brilliancy of the picture, the volume of sound, the movement of the curtains and all those details, which the patrons never notice but which make or mar the picture.'

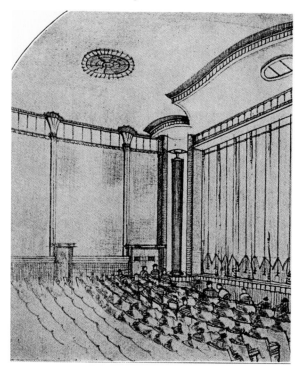

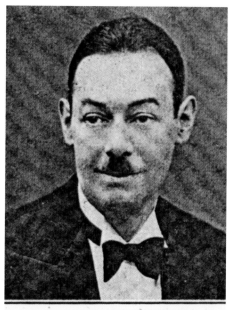

MR. PHILIP E. DAVY

Gaumont Palace VI

At the grand opening ceremony on 15 December 1934, His Worship the Mayor of Yeovil, Alderman A. H. J. Stroud JP, had the privilege of cutting the ribbon, and the guests of honour from the Gaumont-British Studios were Glennis Lorimer and Barry MacKay.

The programme continued with the national anthem, and then the Lila Lee and Onslow Stevens film *Reunion*. British Movietone News newsreels followed, and the evening concluded with the main comedy feature: Tom Walls and Ralph Lynn in *A Cup of Kindness*. For the following week, from 20 December, the programme was replaced by the romantic comedy *It Happened One Night*, directed by Frank Capra and starring Clark Gable.

Philip Davy (*previous page*), who had been manager of the Palace Theatre, was retained as manager of the Gaumont Palace. The programme explained: 'After service in the Army during the Great War, he came to the West of England, and prior to coming to Yeovil had charge of theatres in Sherborne and Ilfracombe.'

Films were screened continuously from 2.30 p.m. to 10.30 p.m., with doors opening at 2 p.m. Adult ticket prices in 1934 ranged from 7d to 2s. The telephone number was simply 158, and free car parking was available at the bottom of Stars Lane.

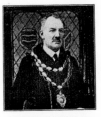

GAUMONT PALACE

The Triangle, YEOVIL

Directed and controlled by the GAUMONT-BRITISH PICTURE CORPORATION LTD

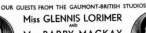

SOUVENIR OF THE OPENING
SATURDAY, 15th DECEMBER, 1934

Opening Ceremony by

His Worship The Mayor of Yeovil

ALDERMAN A. H. J. STROUD, J.P.
(Photo by Witcomb & Son, Yeovil)

— OUR GUESTS FROM THE GAUMONT-BRITISH STUDIOS —

Miss GLENNIS LORIMER
AND
Mr. BARRY MACKAY

Who have kindly consented to appear at the OPENING CEREMONY and the EVENING PERFORMANCES.

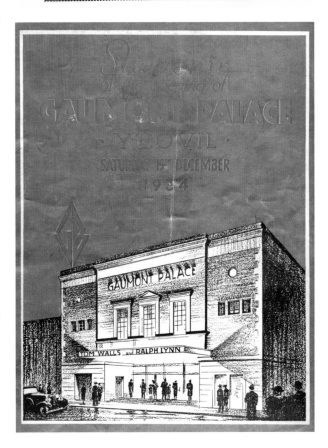

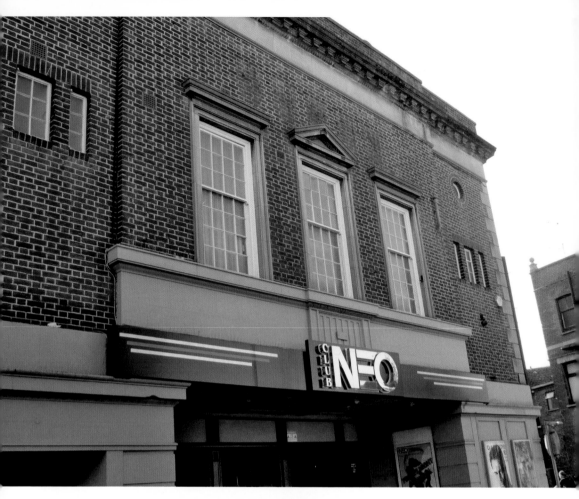

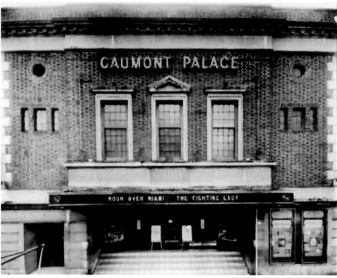

Gaumont Palace VII
In May 1937, pictures showing at the Gaumont Palace included *Libeled Lady*, *The Harmony Parade* (aka *Pigskin Parade*), *The Limping Man*, *The Bride Walks Out* and *Pepper*, with the Coronation of King George VI being presented in 'glorious splendour' on the Thursday, Friday and Saturday. The pictures here show the cinema in 1945 and again in 2012.

Gaumont Palace VIII

There were two cinema clubs for children in Yeovil from the 1940s: the Gaumont British Club and the Children's Club at the Odeon. The Gaumont would start its morning programme with a song, with the words flashed up on the screen accompanied by a bouncing ball for the children to follow. The song went:

> We come along on Saturday morning greeting everybody with a smile,
> We come along on Saturday morning, knowing it is well worthwhile.
> As members of the GB Club we all intend to be
> Good citizens when we grow up and champions of the free.
> We come along on Saturday morning greeting everybody with a smile.

Jack Sweet, who was a member of both clubs, said in 1999: 'There would be more community singing followed by a cartoon, *Mickey Mouse*, etc., the serial – each episode of which would end with the hero being destroyed in various unpleasant ways such as falling over a cliff, but the next week he would stop short just at the edge, and finally the main feature.'

Jack wrote in April 2003: 'On Saturday morning, 5 June 1937, the Gaumont British Kiddies' Club, of which the child star Shirley Temple was president, opened in the Gaumont Cinema in The Triangle. Membership was free and cards to qualify could be obtained from the manager, at the pay box any weekday between 4.30–5.30 p.m., or at the children's matinee on Saturday mornings, admission 6d.

'The clubs were enjoyed by hundreds of children until the dangerous days in the summer and autumn of 1940 when, with the threat of invasion from Nazi-occupied Europe and the bombing of our towns and cities, the Gaumont Kiddies' Club closed in July 1940 and in September, the Odeon Mickey Mouse Club closed until further notice.' (Reproduced by kind permission of Jack Sweet)

To Club Member Jack Sweet

We wish you a very happy birthday.

J. Arthur Rank President

Uncle Phil Club Leader

AF18464

Gaumont Palace IX

In January 1945, the *Yeovil Review* reported: 'What should be of particular interest to boys and girls aged 7–14 is the inauguration of the Gaumont Cinema Junior Club, which will open on 27 January. The idea is that children shall meet socially every Saturday morning in a happy atmosphere, where educational and interesting films, *Secrets of Nature*, travel, etc., will be introduced into the club programmes, after being carefully selected by a committee. The children will be brought into contact with outstanding personalities from all walks of life – people who have distinguished themselves by their contribution to science, literature, art, by their service to their country, or by their efforts for the benefit of mankind. In addition there will be competitions, which the club members will be encouraged to join, and every effort will be made to discover and develop individual talent in this direction. There is no membership fee, and the admission to club meetings and film performances will be 6*d*. Every boy and girl joining will be issued with an official membership card. Last but not least, it is learned that a famous film star will visit the Gaumont Theatre, Yeovil, and officially open the club on 27 January.'

The *Western Gazette* reported that the famous film star was 'Jean Kent, the young Gaumont British star who has appeared in *Fanny by Gaslight* and *Two Thousand Women* and other films, and known to thousands of children as Auntie Jean, for she devotes her free Saturday mornings to visiting Junior Clubs in various parts of the country'.

More than 400 children gathered in the Gaumont on Saturday morning, 27 January 1945, when the Mayor, Councillor W. S. Vosper, opened the inaugural meeting of the club, and told his young audience that in addition to the film shows, Mr Davy, the manager, was arranging for some very interesting people to come and talk to them. Mr Davy thanked the mayor and read telegrams from Tommy Handley (*It's That Man Again!*), Mr J. Arthur Rank, the Club President, the Junior Clubs at Frome and Salisbury, and to applause, a telegram was read from the King and Queen! Club controller, Mr Victor Powell, addressed the young audience and after explaining the club's activities, he introduced the guest of honour, Jean Kent, alias Auntie Jean, who was presented with a bouquet by Margaret Etchells. Auntie Jean presented club badges to six members with birthdays on 7 January, and then led the youngsters in community singing.

Jack Sweet adds: 'I spent many happy hours at the Saturday morning pictures, as we called them, and as birthdays were celebrated with free admission, many of us belonged to both clubs.' One of his birthday cards is reproduced here. (Reproduced by kind permission of Jack Sweet)

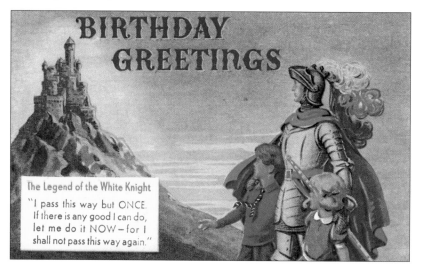

BIRTHDAY GREETINGS

The Legend of the White Knight

"I pass this way but ONCE. If there is any good I can do, let me do it NOW – for I shall not pass this way again."

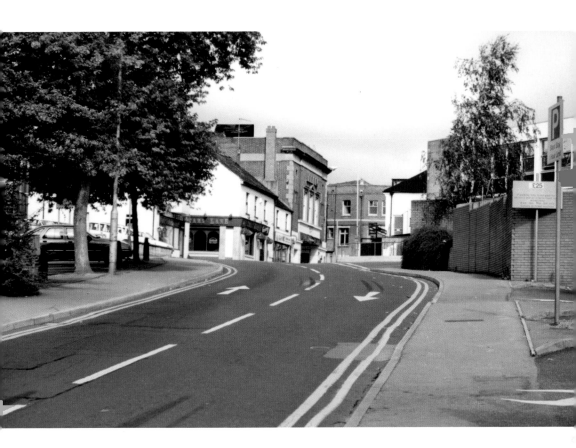

Gaumont Palace X

On 14 December 1948, the *London Gazette* reported that Mark Ostrer, the chairman of Gaumont-British, had put the Albany Ward Theatre Ltd business into liquidation, along with Gaumont Super Cinemas Ltd.

Gaumont sold all its theatres to Rank, which had been running the Odeon circuit since 1941; however, the Board of Trade insisted that Rank's Gaumont and Odeon circuits were run as two separate companies, which is why the Palace was renamed the Classic instead of becoming Yeovil's second Odeon.

From 1947 the cinema was run by the Circuits Management Association, which was formed after J. Arthur Rank (a director of the Gaumont-British Picture Corporation) had also taken control of the Odeon and other associated cinema groups, amalgamating them under his control. At this time the 'Palace' was dropped from the cinema's title, and it simply became the 'Gaumont'.

Ticket prices rose in 1953 to 1s 6d and 4s, and CinemaScope was fitted in the mid-1950s. A decade later, the cinema was deemed surplus to the requirements of Circuits Management Association and was sold to Classic Cinemas in December 1967, who renamed the cinema the Classic. Under Classic's management, the cinema began showing late-night films and special presentations of much-loved old movies. (Photograph by Jack Sweet, 1993, reproduced by kind permission of the Heritage Team, South Somerset District Council.)

Gaumont Palace XI

The rules of the Betting and Gaming Act were revised in 1960, which meant that bingo and similar games that offered a cash prize were now permitted in a cinema. This change simultaneously spelled the death knell for many struggling cinemas, while also saving the buildings as the proprietors switched their trade from cinema to bingo.

Bingo was successfully introduced to the Gaumont several days a week ... so successfully that the Yeovil cinema closed forever for films in November 1972, and the name 'Classic' was transferred to the chain's other Yeovil cinema (the former Odeon on Court Ash), which Classic Cinemas had recently taken over.

The first bingo management company was Vogue, followed by Mecca. It became the Welcome Bingo Hall in 1997, and more recently Top Ten Bingo, who ran the club until it closed for bingo in autumn 2009. The building still stands and externally looks remarkably similar to the 1934 construction. Since 2010, it has operated as the Neo nightclub. On the west wall at the back of the building, if you look closely, you can just make out the camouflage scheme painted on the wall during the Second World War to break up the large building – as shown in the photograph above from 1960. (Photograph above reproduced by kind permission of the Heritage Team, South Somerset District Council)

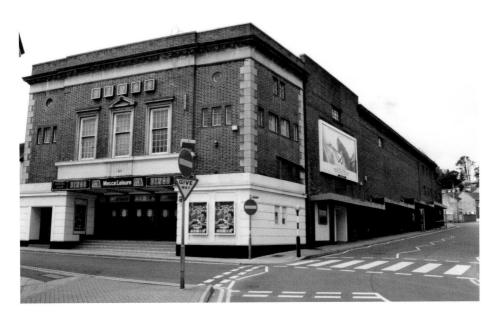

Gaumont Palace XII

The former cinema in two of its incarnations as a bingo hall, the first run by Mecca, photographed in 1993, and the second by Top Ten, photographed in 2009. (Photograph above by Jack Sweet, 1993, reproduced by kind permission of the Heritage Team, South Somerset District Council)

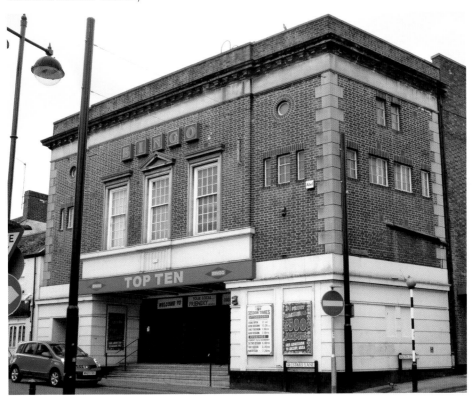

Gaumont Palace XIII

In March 2009, the then-manager of Top Ten Bingo, Duncan Johnston, kindly showed me around the site. Although the cinema became a bingo hall before I was born, it was interesting to see how closely the hall resembled the Art Deco interior depicted in the 1934 programme. The fluted wall lights remained, the grand ceiling plasterwork was still beautifully painted, and the foyer retained the same ticket booth. The 1930s curtains hung behind the stage and the original pulley was still on the wall to operate them, although possibly so rusted up that it might not work. Although the projection room had been given over to pigeons, behind a false wall in front remained ten rows of tiered cinema seats in an area of the building no longer in public use.

Duncan also told me it was rumoured among his staff that the ghost of a former manager haunted the projection room. I wondered if it was the ghost of Mr St Clair, who had died of Spanish Flu in 1918 while managing the Albany Ward cinema.

On 19 September 2009, Duncan told the *Somerset Guardian*: 'The provisional date of closure is 4 October. Due to the ongoing recession, the ban on smoking in public places and with the increase in gross profit tax payable to the government, it is with great regret that we have to announce the closure of the club.'

The struggle that the bingo halls now face is comparable to the struggle cinemas faced in the 1950s when many made the original switch to bingo. The current change in lifestyles – from the rise of online gambling to the 2007 smoking ban – means that many of these wonderful Art Deco palaces are again facing an uncertain future.

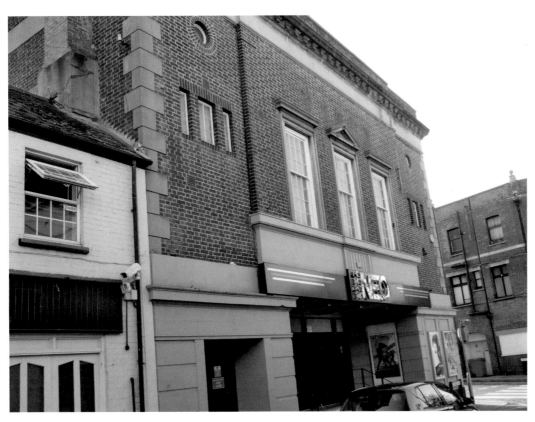

Gaumont Palace XIV
The building reopened in 2010 as the
Neo nightclub, and the manager was
kind enough to give me a backstage tour
in July 2012. The pictures on this page
show the front of the building in 2012.

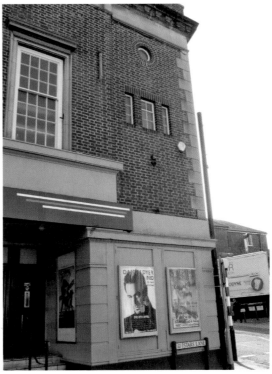

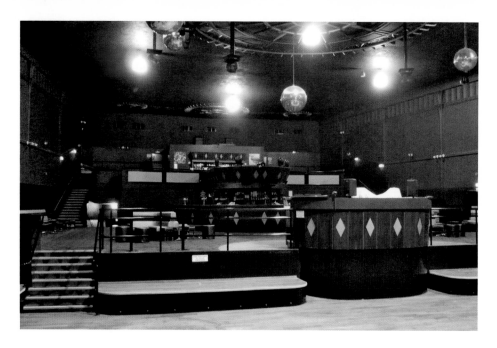

Gaumont Palace XV

The management of Neo has retained almost all of the original features, simply giving them a fresh lick of paint to co-ordinate with the club's colour scheme – and it's a lovely coincidence that Neo's palette of gold and blue is an exact echo of the Gaumont's original gold and blue colour scheme from 1934. It is also great to see that the club's stage remains flanked by the original 1934 fluted pillars (painted gold, as they were back in 1934), and the manager told me that they made a feature of the pillars by having neon lights projected behind them ... just as they did in 1934 (albeit not with neon). In addition, all of the original ceiling roses and plaster wall motifs remain in good order.

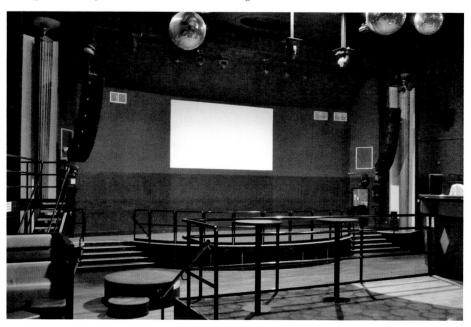

Gaumont Palace XVI

The box office still occupies the same place that was used for the Gaumont in 1934, albeit with a modern refit, and the foyer has kept the original radiators, wall panelling and fluted wall lights. Walking up the stairs to the former auditorium, you really get a feel for what it was like to visit this picture palace to see films during the 1930s and 1940s, despite the change in use. It is to the credit of Neo's management that they have been so sensitive to the building's history and retained as many original features as possible.

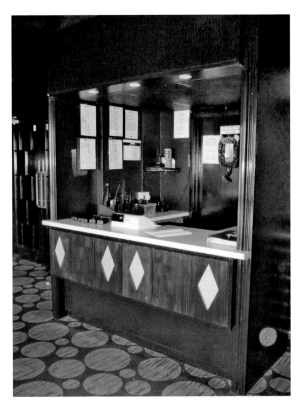

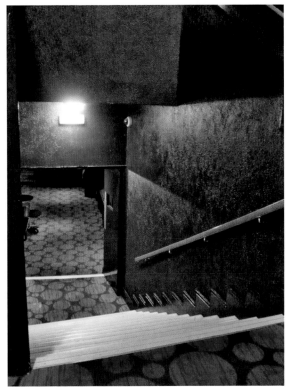

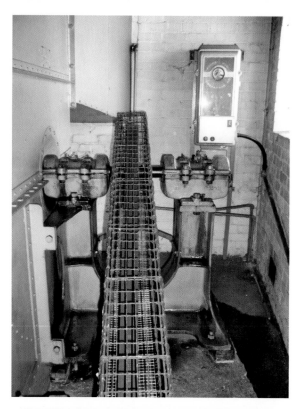

Gaumont Palace XVII
Behind the scenes it is exciting to see that many original 1934 features are still in place, and in the case of the air conditioning system and plenum, they continue to be used every single day.

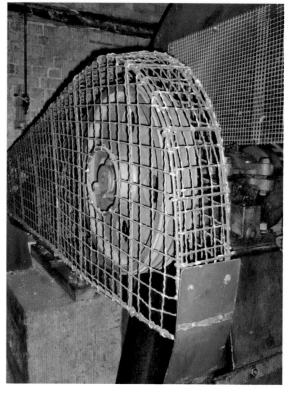

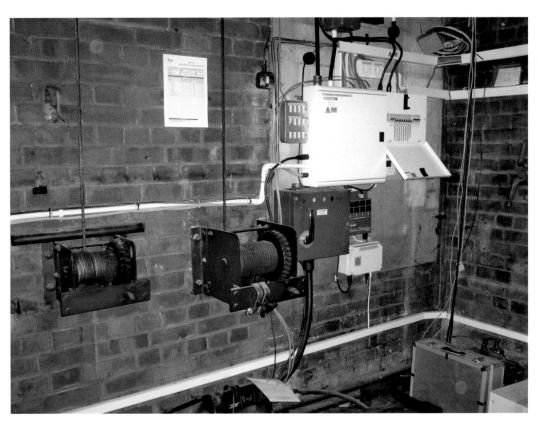

Gaumont Palace XVIII

Behind the stage there are fragments of the cinema's curtains suspended behind a false wall, as well as the original pulleys and their hooks attached to the wall, just as I first saw them in 2009. There are even a few hints at the building's former use, with a few old poster boards propped up in corners, such as this one for *Doctor in the House*, which the cinema screened in 1954. (It is unclear to me why there is a faded Odeon sticker on the bottom of the poster, though.)

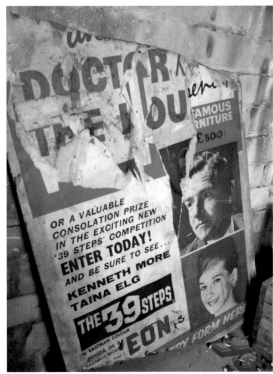

Gaumont Palace XIX

Upstairs, the Gaumont's projection room remains intact, although it is no longer used, and the rear projection windows and their shutters are still on display. The room even has an original cinema queue sign, and seems free of the pigeons that plagued it in 2009. The room beyond the projection room takes you to an outdoor atrium, with doors leading into the former 'switch room' and 're-wind room', with the lettering peeling off the doors – which is forgivable, considering that eighty-one years have passed since the building was constructed.

Gaumont Palace XX

The backstage and upstairs areas of the former Gaumont are a maze of corridors and stairwells, all leading to a variety of hidden treasure troves, including the former manager's office (now used by the club manager as his office), and the cinema manager's former flat, decorated in 1960s fabrics – because he used to live above the cinema. A triangular side room off the plenum also houses the projectionist's former workshop, complete with a bench still laid out with tools and pieces of cinema equipment. It's almost as if the last projectionist in 1972 just put his tools down for a moment and then stepped outside ... not knowing he wouldn't return.

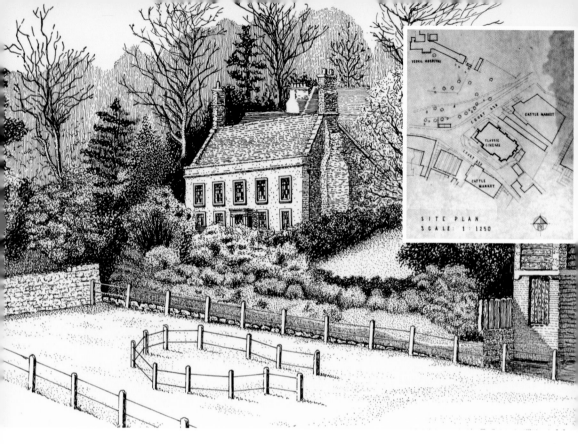

SITE PLAN
SCALE 1 : 1250

Odeon 1

Oscar Deutsch, a Birmingham businessman born in 1893, created the enormous Odeon chain ('Oscar Deutsch Entertains Our Nation') with jaw-dropping efficiency. Between 1933, when he founded the chain, and 1941, when he died from cancer aged just forty-eight, Deutsch opened a humbling 258 Odeon cinemas. More than half of these were in purpose-built buildings that typically resembled ocean liners stranded on a suburban high street. As such, Deutsch greatly helped stimulate the British building industry at a time when the effects of the Depression were still ricocheting around the country. The contemporary architecture of the Odeons was a promise of the shape of things to come, with their trademark tower fins and broad, sweeping lines.

A plot at Court Ash Terrace in Yeovil suited Deutsch's needs perfectly. Previously occupied by terraced houses and the imposing Court Ash House (*above*), the site was in use as a car park for the nearby Vincents showroom when plans for Deutsch's super-cinema began (Stanley Vincent would shortly become an investor in and director of the Yeovil Odeon). A thriving cattle market dating back to the 1850s was also on the site, and it survived alongside the cinema until the early 2000s.

As was his custom, Deutsch formed a local company, Odeon (Yeovil) Ltd, to promote the cinema, although this was later absorbed into his main circuit before being put into a holding company in 1940 Odeon (Properties) Ltd. However, the Yeovil Odeon was different to Deutsch's usual provincial set-ups ... because this one was the prototype for his flagship Odeon cinema in London's Leicester Square, which was to open six months after the Yeovil cinema. For this reason, there was extra attention to detail with the Yeovil Odeon, which cost £70,000 to construct. (Drawing by Leslie Brook, reprinted by kind permission of David Brook; site plan from 1972)

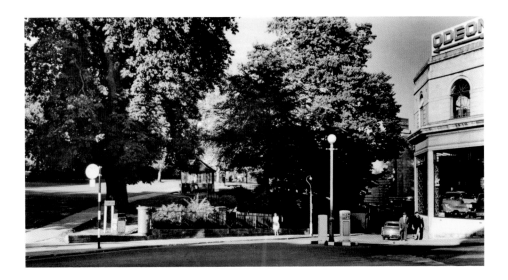

Odeon II

In November 1936, the *Yeovil Review* teased readers by writing of the forthcoming cinema: 'The character of the building has been given functional expression in choice of facing materials, which consist of mottled golden faience, black faience base with green sunk insert bands [which would have been reinforced with neon tubing that lit up at night] and thin grey-brown facing bricks with projecting decorative courses. A prominent feature is the slab tower with projecting faience fins, and illuminated at night by coloured neon tubing.'

The Reckleford dual carriageway that now occupies the space beside the Odeon did not exist in the 1930s. In its place was Bides Gardens, which was also to become the site of Yeovil District Hospital in 1973. The gardens were named after Thomas William Dampier-Bide, who bequeathed the grounds to the town in 1916. The picture shows the corner of Vincents showroom in the 1950s, leading to Bides Gardens on the left and the Odeon straight ahead. The second photograph shows the same view in 2012; the dual carriageway is behind the trees. (Photograph above from the Cave Collection, 1965, reproduced by kind permission of the Heritage Team, South Somerset District Council)

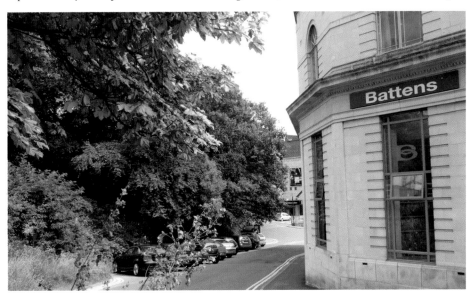

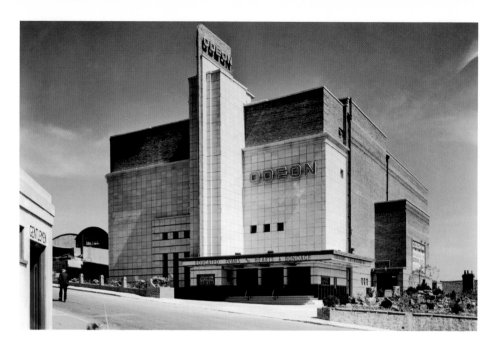

Odeon III

Harry Weedon was the principal architect for the Odeon, assisted by Budge Reid who worked in his office. Weedon was a Birmingham architect who is best known for designing many of the Odeons of the 1930s. It is argued that Weedon's sleek and modernist Odeon cinemas encouraged traditional-loving Brits out of a design slump and helped them to appreciate contemporary architecture in a way that could only be rivalled by the architecture of the 1930s London Underground stations. Weedon came to Deutsch's attention after designing a factory in Birmingham in 1932, which was owned by Deutch's father. Deutsch Jr was looking for an architect for his cinema empire and liked what he saw in Weedon's work. Between 1934 and 1939, Weedon and his office designed or consulted on more than 250 Odeon cinemas. The Odeon is shown here in 1937 and 1989; only British materials were used in the construction of the cinema. (Photograph above by John Maltby 1937, reproduced by kind permission of English Heritage; photograph below by Ben Doman, 1989)

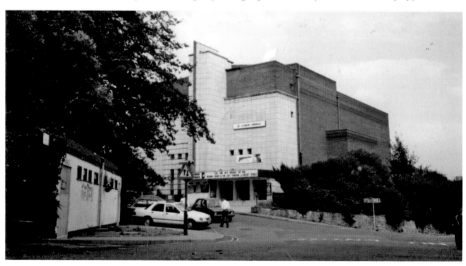

Odeon IV

Weedon's firm was so absorbed with cinema design in the 1930s that he recruited a number of young architects to work solely on the Odeons. Robert Bullivant was one such architect, and he worked closely with Weedon on the Odeon expansion from 1935. Alongside Weedon, Bullivant helped to ensure the Odeon design was an instantly recognisable brand. The Odeons of the 1930s were therefore ultra-modern, and tended to be huge, cream-coloured buildings, clad in faience tiles and outlined in neon at night. In 1985, Bullivant recalled: 'The high point of my life was the period 1935 to 1939. Thereafter, almost everything has been an anti-climax.'

Neon was a significant part of the cinema's external design, and the *Yeovil Review* wrote in May 1937: 'Externally, the theatre will present a striking effect by night as well as by day. Neon lighting has been designed as an external part of the façade.'

Following the early death of Deutsch (pictured) in 1941, and the takeover of the Odeon group by J. Arthur Rank, the attention to architectural detail that his cinemas had previously enjoyed was gone. Alongside this, Weedon's time was now taken up with helping to rebuild Birmingham's industrial buildings that had been destroyed or damaged in the Blitz, and he never made a significant return to cinema architecture. Weedon Partnership Architects continues to have an office in Birmingham.

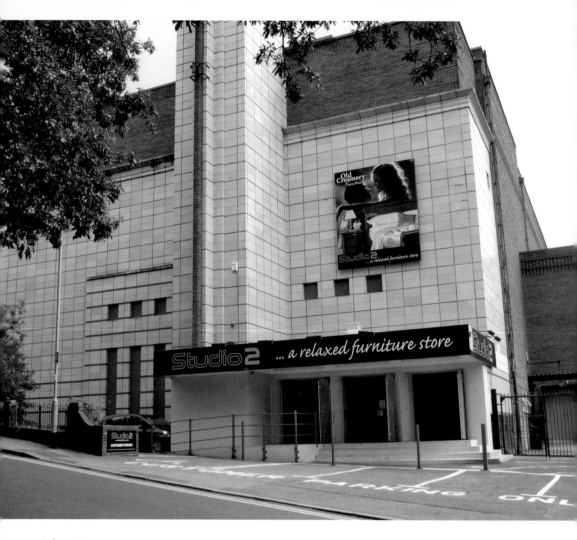

Odeon V

Ben Doman was the cinema's projectionist in the early 1990s, and he explains what was behind all the tiny windows on the front of the cinema: 'Behind the line of three small windows above the canopy was the battery room. The three at the same level on the left of the tower (if you're facing the cinema) were the sweet kiosk opposite the entrance to Screen One. This was originally the projectionist staffroom. The small window on the right side of the building [just visible in the photograph], on the tiles, was a small room at the rear of Screen One where the letters for the canopy's lettered signs were kept.'

The finished building could hold 1,580 patrons, 978 of whom were in the stalls. A stage area had been built below the screen, and British Thomson-Houston sound was fitted to carry the music and speech.

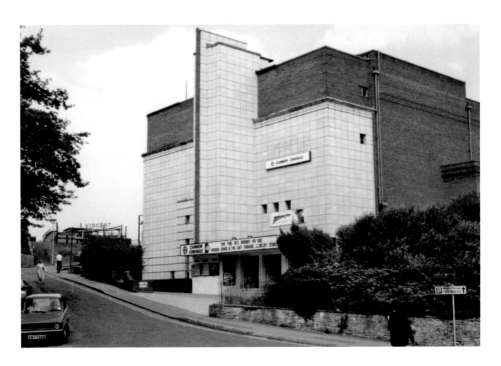

Odeon VI

The exterior of the building has survived relatively unchanged between 1937 and 2012, apart from obvious changes of signage depending on which chain is running the cinema, and more recently for its newer use as a furniture shop. The only significant change is the loss of the Odeon fin at the top of the central tower, which fell during storms in the 1960s and was never replaced. The photographs here are from 1989 and 2012. (Photograph above by Ben Doman, 1989)

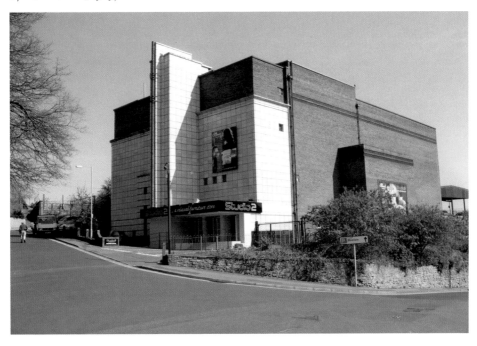

Odeon VII

The front steps and entrance to the cinema also remain largely unchanged. The photographs here are from 1989 and 2009, and apart from a change of colour scheme, the main alteration is that the canopy has been re-covered to allow for shop signage. At ground level, pillars have been added at the base of the steps, plus railings between the steps, and a ramp for access has been put on one side. However, the 1937 green bands around the tiles on the steps remain to this day. (Photographs above by Ben Doman, 1989)

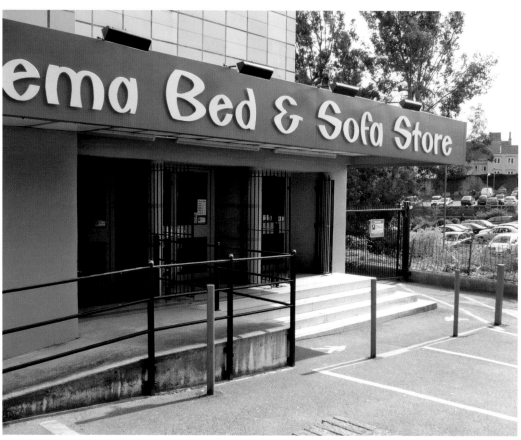

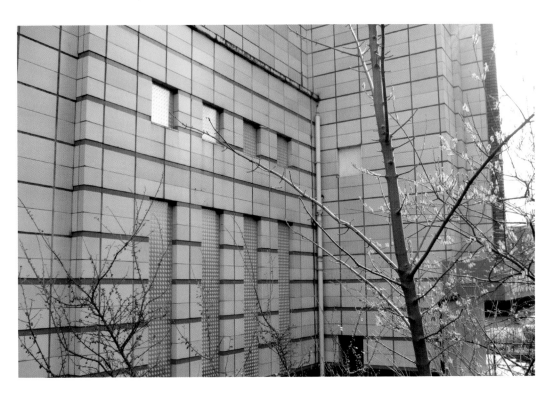

Odeon VIII

Ben Doman retrospectively offers a descriptive tour of the behind-the-scenes areas: 'At the front exits of Screens Two and Three were small rooms. In the left one (Screen Three) there was the long-disused vacuum plant. Popular in cinemas of the 1930s and 1940s, before portable vacuum cleaners, cinema cleaners would take the vacuum hose around with them and plug it into the various outlets around the cinema. Pipes would lead back to a powerful pump that emptied the dirt into a giant receptacle that was emptied daily.

'A spiral staircase led up to a further room where there was an extractor fan. The room opposite Screen Two also housed an extractor fan, but the spiral staircase carried on up from this into another room which housed the Holophane dimmers. The dimmers had a long arm that moved across a resistance network to vary the lighting levels, and were controlled by motors. There were several of these dimmers controlling different light circuits in the cinema. The dimmers are now in the cinema museum, housed in the former Odeon in Newport (a listed building that was also designed by Harry Weedon).

'A door on the opposite end of the foyer led down some stairs to the plenum chamber (a pressurised space that stored the dirty air from the auditorium), manager's office and store for the kiosk. The distinctive tower on the front housed, at foyer level, the main electrical switch room. A door behind the kiosk at the entrance to Screen One led into the tower and stairs up to Screen One's projection room. The tower suffered from damp penetration and the decision was taken to coat the tiles on the outside of the building with a waterproof paint. Two shades of biscuit-colour paint were used to replicate the basketweave design of the tiles, and the joints between painted black. Local builders spent weeks painting the tiles but sadly, during the next winter, we found the tower still leaked.

'Ever taking pride in our workplace (Screen One's projection room still had a beautifully polished parquet floor), we felt that the boiler house needed sprucing up. Told to use whatever paint was left from the last refit, we found that the only colour left in any quantity was pink. Visiting boiler engineers were threatened with the withdrawal of their tea privileges if they dared make fun of our pink boiler house!'

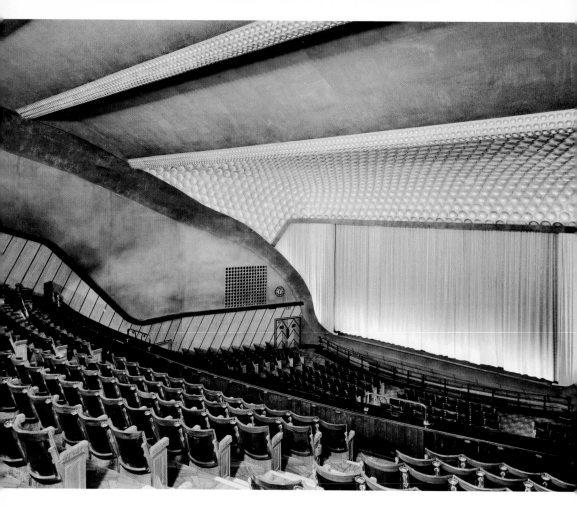

Odeon IX

Apart from anything else, the Yeovil Odeon was unique because of its impressive use of the Holophane lighting system. Above the proscenium arch there was (and still is) a huge area of small, circular, plaster dishes, laid out in a honeycomb pattern and painted gold. These were lit by a three-colour lighting system from Holophane.

Founded in London in 1898, Holophane is one of the oldest manufacturers of lighting products in the world. Holophane's hallmark product is a borosilicate glass reflector/refractor: the glass prisms provide a combination of uplight and downlight to illuminate any environment evenly without dark spots or glare. Holophane's theatre lighting department became renowned for its equipment, prowess and enthusiasm with colour lighting for the stage and auditorium. In the pre-war years, cinema lighting was an extremely lucrative business thanks to the boom in building new cinemas.

This picture shows the auditorium in 1937, with the plaster dishes above the stage curtain. (Photograph by John Maltby 1937, reproduced by kind permission of English Heritage)

Odeon X

Rollo Gillespie Williams ran Holophane's theatre lighting department, and Tim Hatcher writes in *Picture House* magazine: 'Williams' career was dominated entirely by a passion for mixing coloured light, and this dedication found expression in the invention of efficient and effective colour lighting sources for auditorium and automatic means to control them, in the creation of decorative light fittings incorporating colour change effects, in the design of stage settings, draperies and auditorium surfaces onto which the colour could play, and even in the composition of the auditorium itself as a receptor for coloured light.

'The principle of colour mixing of light is simple: if the beams of three light sources are directed onto the same area of a white surface, and their relative intensities varied, as by dimmer control, the visual sensation of most of the hues in the visible spectrum, and some not therein – the purple line – may be produced.'

The pictures show the plaster dishes in 2009, still painted gold, and looking even more prominent because you can see them in close proximity in the building's new use as a furniture shop.

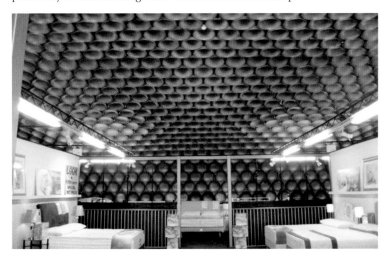

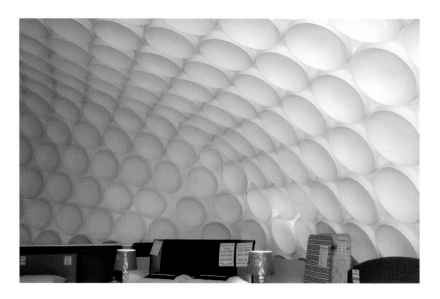

Odeon XI

Rollo Williams designed repetitive features of varying contour to cover large expanses of walls or ceiling space – recurrent convex, concave and other three-dimensional compositions, 'combed' squares in alternative right-angled configuration, courses of bulbous linear mouldings. In 1934, he named this the Moulded Contour system. There were also troughs containing concealed lighting in the ceiling, again with Holophane lighting.

Celebrating the opening of the cinema, the *Yeovil Review* wrote in May 1937: 'Lighting generally will be concealed, relying mainly on a new system of ever-changing colour combinations of restful pastel shades for delightful effects and tone variation.' Holophane quit the entertainment lighting industry in 1942, but still operates as a manufacturer of commercial and industrial lighting.

The carpets and upholstery were deliberately dark, while the adjacent walls were given a non-reflective treatment and the lighting was kept to a minimum. The pictures show the plaster dishes in 2012, now painted white and with all damaged dishes repaired.

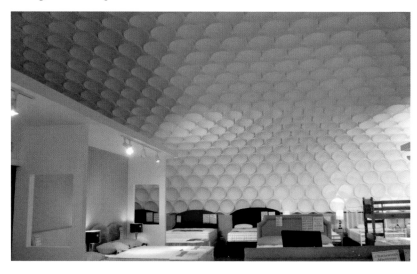

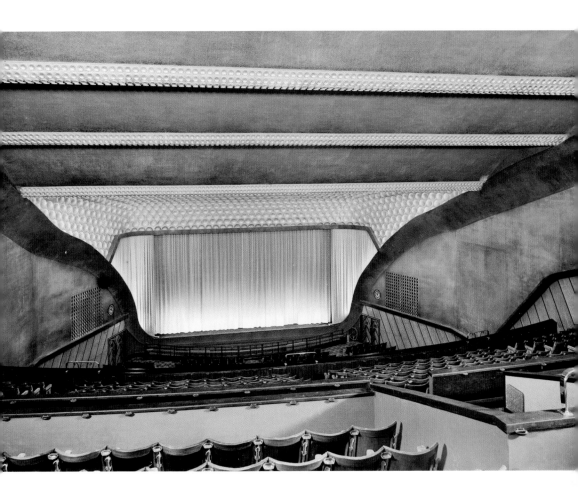

Odeon XII

Michael Egan was a flamboyant interior designer who was swept up by the need for bold and effective cinema interiors in the 1930s. In that decade, Egan designed a high number of innovative, stylish yet functional cinema interiors, including the Yeovil Odeon. Looking back on his move into cinema design, Egan later said: 'Things were very bad in 1931 in England. There was no work at all, except in cinemas.'

In 1931, Egan started to collaborate with a Russian designer called Eugene Mollo, and they set up business as interior design contractors called Mollo & Egan. Typically, Mollo worked on vivid murals, painted decorations and bright carpets. Egan was involved with decorative plasterwork and the more structural aspects of their designs.

This picture shows the interior of the auditorium in 1937. (Photograph by John Maltby 1937, reproduced by kind permission of English Heritage)

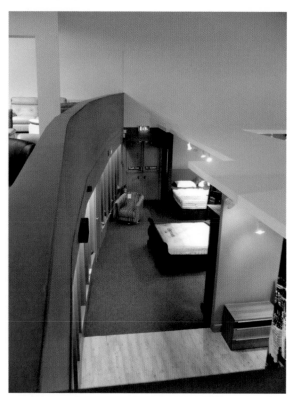

Odeon XIII

Writing in *The Independent* in 2003, Allen Eyles said: 'Mollo and Egan designed a striking auditorium scheme for the Odeon Yeovil, which relied on reflected light. "The thing was to provide reflecting surfaces. It was done by projectors from a number of sources. It wasn't static and the light would be changing all the time, on dimmers," Egan recalled. At Yeovil, the Gaumont Rose Hill and the Odeon North Watford, the team pioneered the continuation of the brightly-lit ceiling down the side walls to a diagonal line descending towards the screen.'

The pictures here show the interior of the former Odeon in 2012, and by standing on the former balcony you can clearly see the former projection room windows.

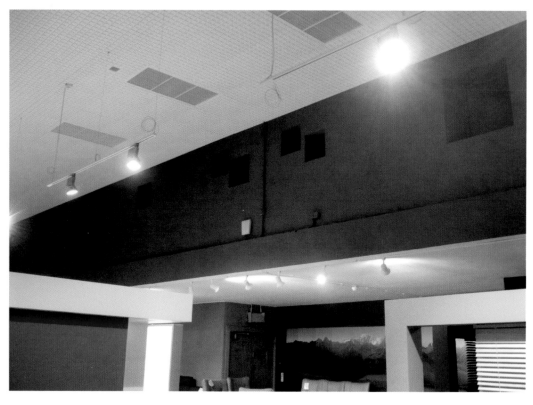

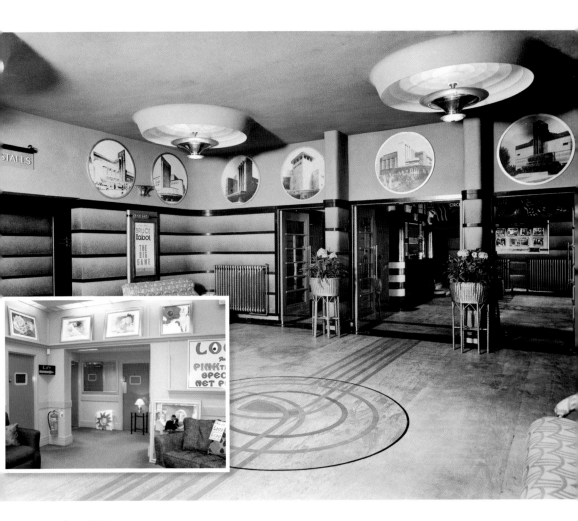

Odeon XIV

Deutsch's wife Lily (billed as 'charming and capable' in the programme) also helped design the interior of the Yeovil Odeon, as she did with many others in the circuit. The opening night programme said: 'Many hours have been devoted to the careful study of the colour scheme. The colours of the auditorium walls and ceiling, seat covering, carpet, rubber flooring, etc., have all been studied both individually and collectively before a decision was reached.' In the early 1990s, the original orange and red 'autumn colours' carpet that Lily had chosen was uncovered when the newer stair carpet was lifted for cleaning ... it was reverentially covered back up.

By the 1960s, decades of patrons smoking inside the cinema had caused the fibrous plasterwork to look dirty and stained, and many cinemas were given a dramatic makeover. At this time, a lot of Mollo & Egan's 1930s plasterwork designs were destroyed; however in Yeovil the designs survived and were cleaned up. The Odeon did not become a non-smoking cinema until 1987.

The pictures show the foyer in 1937 and 2009. It is almost unrecognisable, despite the continued inclusion of sofas in the space! The 2009 signage to a lift also hints at a feature that was installed after the cinema closed. (Photograph above by John Maltby 1937, reproduced by kind permission of English Heritage)

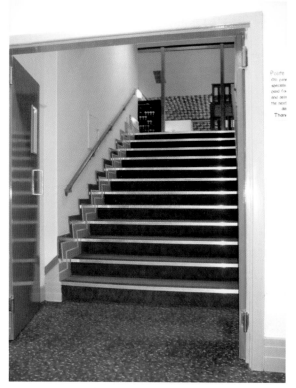

Odeon XV

Many of the 1937 details of the interior remain, such as the layered woodwork around the skirting of all staircases and doorframes. Elsewhere, many of the doors are from 1937, and retain the intricate Art Deco detailing despite a few coats of paint. In these pictures, those with a green scheme are from 2009, and the staircase leads you into the former Screen One: the speckled carpet was left from the ABC cinema. The photograph with white paintwork is from 2012, and this staircase would have taken you up the right-hand-side of the cinema into the main auditorium.

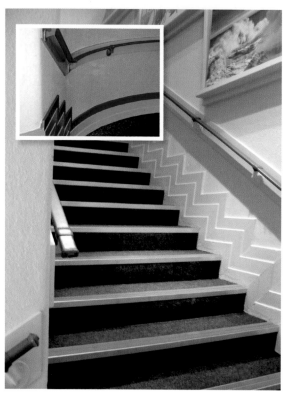

Odeon XVI

These pictures were taken inside the former manager's office in 2012, and the poster on the wall above the desk still bears the Odeon branding. The room is no longer used but, along with many of the behind-the-scenes offices and storage rooms, still has the 1937 parquet flooring. Upstairs, above the furniture shop and former auditorium, is a maze of now-unused corridors, storerooms, staff restrooms and more, all with parquet flooring, and many with original signs on the doors and empty shelving inside.

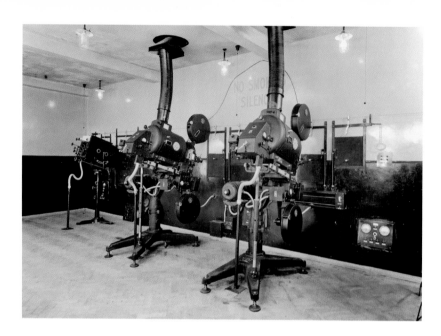

Odeon XVII

John Maltby was a photographer who rose to great prominence in the 1930s when the camera started to influence architectural practice and criticism in a way that had never been seen before. Maltby won a lucrative commission from Deutsch to document all of the Odeons in his chain, and by 1939 he had taken 1,100 photographs of 250 Odeons. Robert Elwell wrote: 'Maltby's depictions of glittering Art Deco dream houses with their streamlined, cream-tiled fronts, brash lettering and boldly accentuated towers ... have continued to provide some of the images most redolent of the 1930s.'

Reproduced here is Maltby's photograph of the Yeovil Odeon projection room in 1937, alongside my own from 2012, taken at a similar angle. (Reproduced by kind permission of English Heritage)

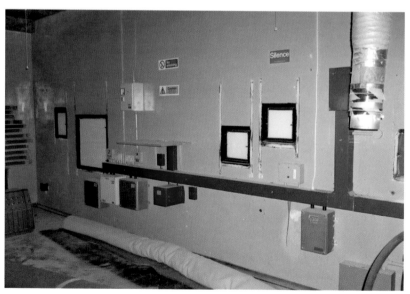

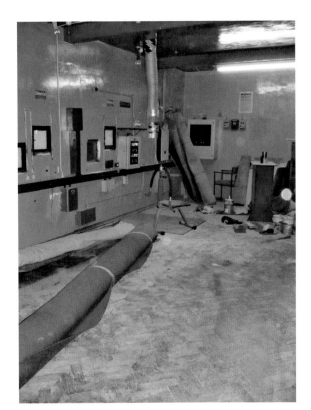

Odeon XVIII

These photographs of the former projection room, also taken in 2012, show the parquet flooring, which was reportedly kept well polished right up until the cinema closed. The second picture shows an operations box, marked up with cinematic information and instructions.

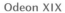

Odeon XIX

Behind a false wall at the back of the ground floor of the furniture shop lies the former stage and screen of the main Screen One auditorium. This area is now accessed through a door at the rear of the building, and alongside the Georgian red brickwork you can see the 1937 curtain pulley, the ladder leading into the roof space, plus fragments of curtain still hanging in the rafters and exposed original floorboards.

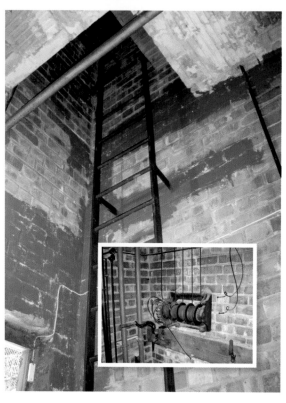

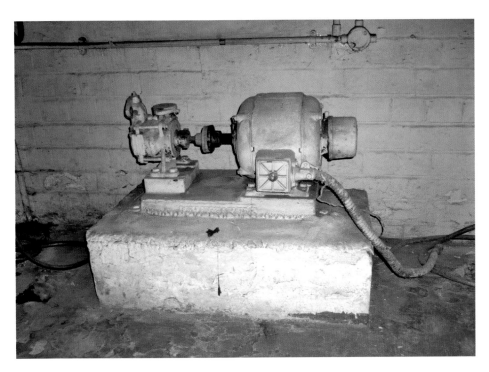

Odeon XX

Underneath the cinema is the old boiler room, which like many of the original plumbing features (albeit with a little contemporary adjustment to keep them going), is still being used for its original purpose – to heat the building.

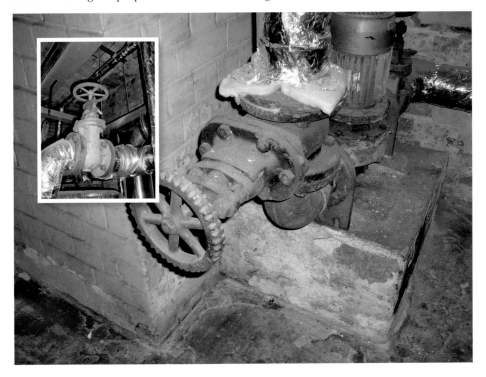

Odeon XXI

The grand opening ceremony was held on 10 May 1937. 'The coming of the Odeon is an epoch in the entertainment life of Yeovil,' boasted the programme. 'It is a distinct and unique addition to the amenities of the town, and those who have pioneered in the past must regard it as a compliment that their enterprise has made this theatre possible.'

The first resident manager was a Canadian, Mr A. P. Purvis (pictured), who had managed Odeon cinemas in Bristol and Plymouth. In the souvenir programme it said: 'His ambition is to make the Odeon the leading house of entertainment in Yeovil and the efforts of himself and his staff will be untiringly directed to that end.'

COURT ASH YEOVIL **ODEON** COURT ASH YEOVIL

SATURDAY, MAY 8th at 8 p.m. Doors Open 7.15 p.m.

Grand OPENING CEREMONY

:: :: BY :: ::

SIR GEORGE DAVIES, J.P., M.P.
(Vice-Chamberlain to H.M. Household) supported by

HIS WORSHIP THE MAYOR
(ALD. S. C. CLOTHIER)).

Special Engagement of the Band of the 1st Battalion

THE ROYAL SCOTS

(The Royal Regiment) by kind permission of Lt.-Col. E. H. de STACPOOLE, M.C. and Officers of the Regiment. - Bandmaster: Mr. H. C. MACPHERSON.

ON THE SCREEN

GEORGE FORMBY in "KEEP YOUR SEATS PLEASE" (U)

STARLIT DAYS AT THE LIDO and A COLOURED CARTOON
(COLOURED MUSICAL) —NEWS—

ADMISSION BY TICKET ONLY.

Special Coronation Week Programme.	
MONDAY, TUESDAY, WEDNESDAY, MAY 10th, 11th, 12th.	THURSDAY, FRIDAY, SATURDAY, MAY 13th, 14th, 15th.
GEORGE FORMBY in	KATHERINE HEPBURN & HERBERT MARSHALL in
KEEP YOUR SEATS PLEASE	**A WOMAN REBELS**
(U) showing at 3.15, 6.10 and 9.10. also	(A) showing at 3.10, 6.15, 9.15 also
RALPH BELLAMY in	CHESTER MORRIS and FAY WRAY in
THE MAN WHO LIVED TWICE	**THEY MET IN A TAXI** (U)
showing at 2, 4.55, 7.50	Also COLOURED CARTOON—DONALD & PLUTO
DOORS OPEN 1.45. COMMENCE 2 p.m.	DOORS OPEN 1.45. COMMENCE 2 p.m.
Last Performance begins at 7.50	Last Performance begins at 8 p.m.

☞ Come to the Odeon on Coronation Day and hear the King's Speech broadcast in comfort whilst enjoying the complete programme.

Odeon XXII

The opening night was a packed affair, with tickets having sold out just two hours after going on sale. Beginning with a welcome by Sir George Davies JP MP, and His Worship The Mayor Alderman S. C. Clothier, at 7.15 p.m. After music from the Band of the First Battalion, The Royal Scots, the film programme included British Movietone News, a 'coloured musical' called *Starlit Days At The Lido*, a 'coloured cartoon' called *The Lost Chick*, before the main presentation of *Keep Your Seats Please* (a 1936 comedy musical starring George Formby and Florence Desmond).

In his speech, Sir George Davies, who was MP for Yeovil at the time, remarked on the 'beauty' of the Odeon, and paid tribute to the architect (Harry Weedon) and builder (John Knox) who were present. He also expressed pleasure at seeing Deutsch there ('the man behind the big guns') and his wife, whose taste and experience had provided the beautiful interior design. Sir George added that he was no fan of films and favoured 'real legs', but said it would be 'idle' to deny the enormous strides made in the world of cinema in recent years – before admitting he missed the silent films with absurd captions that audiences chanted aloud.

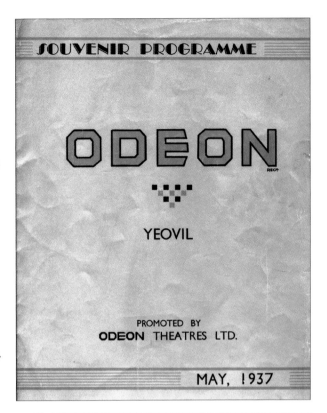

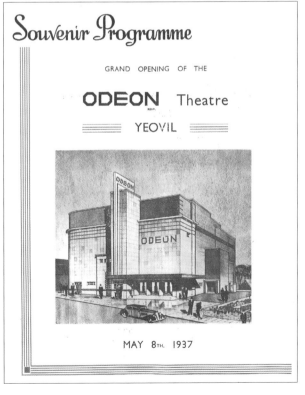

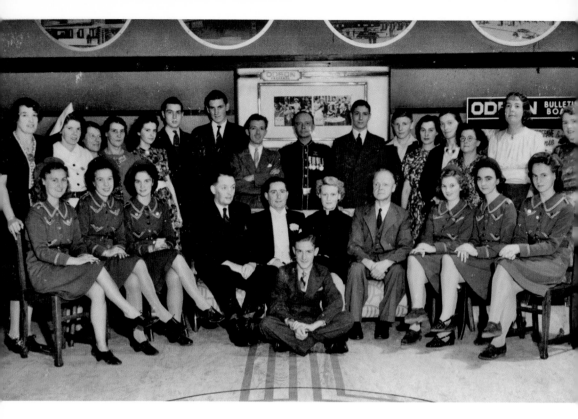

Odeon XXIII

The Coronation Week programme continued with *Keep Your Seats Please* headlining until the Wednesday, supported by *The Man Who Lived Twice*. It was succeeded by *A Woman Rebels* (a 1936 Katherine Hepburn film). On Coronation Day, patrons were promised that they could hear the King's speech broadcast in comfort ... assuming it arrived from London in time! Until the war began in 1939, the Odeon opened daily at 1 p.m., and the price of tickets ranged between 6d and 2s in the evenings, and 4d to 1s for a matinee.

This photograph of the Odeon's staff was taken in the cinema's foyer in 1940. In the centre is manager Ernie Brown with his wife, and their son is seated on the floor. Sitting beside Ernie Brown is car salesman Stanley Vincent, who Deutsch had enlisted as an original director of the cinema. The shorter man beside the commissionaire is John Clark, the chief projectionist. Tony Robins, who has lived in Yeovil all his life, adds: 'I well remember Mr Brown, the manager of the Odeon, who always stood in the foyer in an evening suit and bow tie, and always greeted the film-goers as they came in.' (Photograph reproduced by kind permission of the Heritage Team, South Somerset District Council)

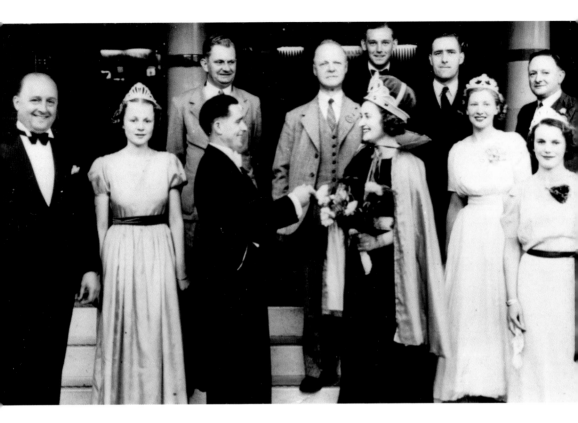

Odeon XXIV

In 1940, prices were 6*d* to 2*s*, but after the war ended they rose to 1*s* and 3*s* 6*d*. On VE Day (8 May 1945), the Odeon was screening *And Now Tomorrow* (a 1944 drama), when the news of peace was broken to audiences by a newsflash. Audiences stood on their seats and cheered the news. However, the cinema fulfilled more of a role in the community than merely being an entertainment centre. For instance, the 50th anniversary carnival of the Yeovil Co-operative Society in 1939 concluded with the crowning of Yeovil's carnival queen at the Odeon. The photograph shows the crowned queen standing on the steps of the cinema with her entourage. (Photograph reproduced by kind permission of the Heritage Team, South Somerset District Council)

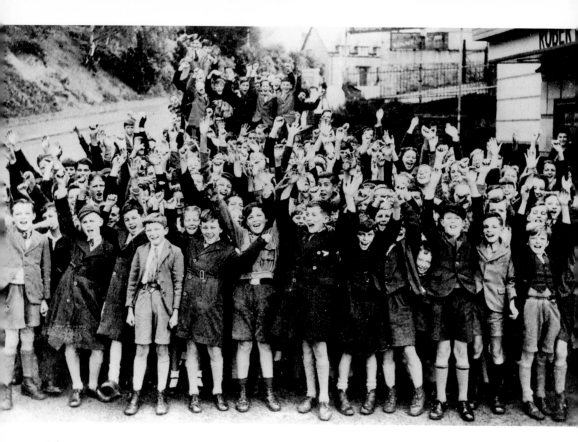

Odeon XXV

By 1947, the Odeon's Saturday morning cinema club for children was packed with youngsters eager to exchange their pocket money for films.

Jack Sweet wrote in April 2003: 'The Odeon club followed a similar programme to the Gaumont, but the main song was a road safety one set to the tune of 'The Lambeth Walk'. All the Odeon seats in the stalls were 6d and up in the balcony they were 9d. There was always the temptation, quite often succumbed to by the residents of the balcony, to drop things onto the heads of the denizens of the stalls. At the end of the show, many of us would charge across Court Ash and up the bank into Bide's Gardens, slapping our sides pretending we were cowboys or cavaliers on horseback. Birthdays were celebrated by a free admission and many belonged to both clubs to get two free Saturdays.'

He continued: 'On 5 June 1937, one month after the cinema opened in Court Ash, the new Mickey Mouse Matinee Club opened with a feature film, news, a cartoon and the first episode of *The Phantom Rider*. The doors opened at 9.45 a.m., membership was free and club badges were awarded after three weeks' attendance. Admission was 3/6.'

The Second World War closed the club for a few years, but on 10 April 1942 the Odeon's weekly advertisement of forthcoming films in the local paper announced the reopening of the club, now renamed the Odeon National Cinema Club for Boys and Girls. (This photograph is thought to have been loaned to the Museum of South Somerset in 1995 for inclusion in the following title: *Around Yeovil* by Robin Ansell and Marion Barnes. Every attempt has been made to contact the original owner. If anyone has information on the photograph, please contact the publisher and credit will be given in any future reprints)

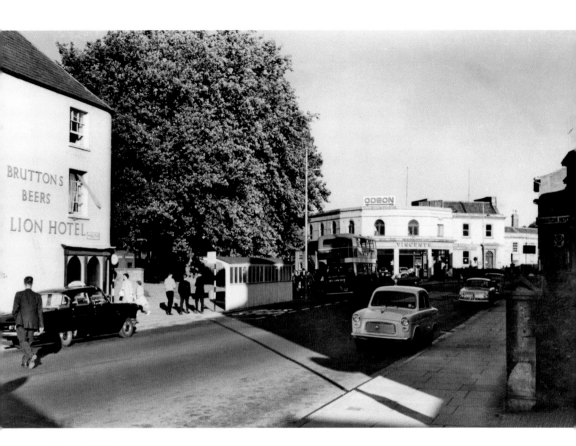

Odeon XXVI

When the Great Train Robbery took place on 8 August 1963, nobody knew the role the Yeovil Odeon had played in enabling Ronnie Biggs to take part. During the robbery, £2.6 million in used banknotes was stolen from a mail train in Buckinghamshire, and the driver Jack Mills was beaten with an iron bar. The bulk of the stolen money was never recovered.

Before Biggs could take part in the robbery, he needed £100 to help bankroll the heist. He found that money by breaking into the Yeovil Odeon (which was showing the Cliff Richard film *Summer Holiday* at the time) and stealing the day's takings, as well as staff wages, from the safe.

Ronnie's ex-wife Charmaine laid the blame at her husband's feet, and explained in 2001 that she and Ronnie were holidaying in the town at the time of the cinema robbery. Ronnie later denied Charmaine's story, although he did say: 'I know Yeovil quite well and have been there a number of times.' However, back in 1963, Yeovil detectives were baffled by the crime at the cinema, because no fingerprints or other evidence were found and no witnesses came forward, implying that the job was a professional one.

The picture shows the corner of Court Ash in the 1960s, with a sign to the Odeon on top of Vincents car showroom, at the time of Biggs' alleged robbery. (Photograph from the Cave Collection, 1965, reproduced by kind permission of the Heritage Team, South Somerset District Council)

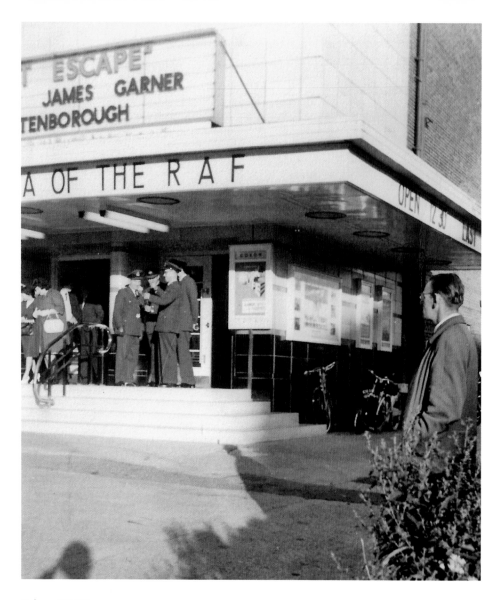

Odeon XXVII

Ben Tucker, who worked at the cinema during its entire sixty-five-year run, was the projectionist when Biggs broke in. Speaking in 2001, Ben described the scene when he turned up for work the following day: 'I saw the office door had been broken open. Inside, the safe was empty. I went round the back and saw that the exit door had a hole drilled through it and the lock had been picked. There were no clues left behind and the police got nowhere with it. I didn't know Ronnie Biggs might have been involved until his wife spoke out. I don't see why she would lie.'

Biggs' connections to the West Country date back to the Second World War when he was evacuated to Devon. Fellow train-robber Buster Edwards once said that he and Biggs found the West Country to be a 'very profitable spot'. Plans for the robbery were found in a cavity wall in a house in nearby Taunton in 1969.

Pictured here are RAF personnel queuing to see *The Great Escape* at the Odeon in 1963, the year of Biggs' alleged robbery.

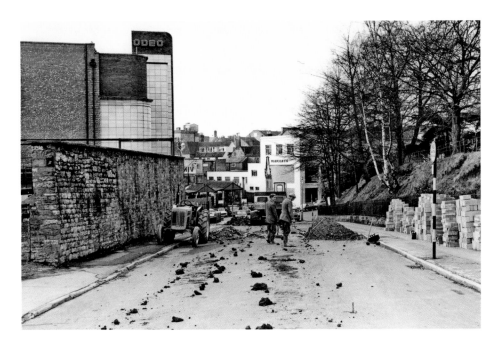

Odeon XXVIII

The proximity of the Art Deco Odeon to the traditional 1850s cattle market was always a pleasing contrast in the Yeovil townscape, and the barrel-vaulted, corrugated-iron roofs of the market sat incongruously alongside the sleek, tile-clad, neon-illuminated façade of the Odeon. The first picture is from January 1966, and shows tractors making their muddy way up Court Ash to the market, while the second photograph from 2012 shows the now abandoned market sheds, overgrown by shrubbery, but still poking out beside the former cinema. The cattle market closed in 2008 after 156 years, with the intention being to redevelop the land into housing. Four years later, there has been no progress. (Photograph above by Rendell, January 1966, reproduced by kind permission of the Heritage Team, South Somerset District Council)

"ONE OF THE HOUSES THAT C.D.C. BUILT" . . . the main reception foyers at the Classic Entertainment Centre, Yeovil, Somerset after completion of modernisation and conversion to triple auditoria by CO-ORDINATION OF DESIGN & CONSTRUCTION LTD., CURZON BUILDINGS, LANGNEY ROAD, EASTBOURNE, (Tel: 31441/21186). C.D.C. are at present undertaking modernisations and conversions at MANCHESTER, FOLKESTONE, WESTCLIFFE and SOUTHPORT.

Odeon XXIX

In October 1948, Odeon Theatres had a £13.6 million overdraft, the following year it rose to £16.3 million. This was due to the government's tax on imported films and the growing dominance of the Rank group. In 1958, John Davis (Rank company secretary) decided to merge the Odeon and Gaumont circuits into a single circuit and by 1960 the only two cinema circuits in the UK were Odeon and ABC.

In the late 1960s, the cinema was affected by a freak hurricane. Projectionist Ben Tucker said: 'There were about 200 people queuing up outside and we decided to move quickly to get them in. About five minutes later, the Odeon fin on top of the cinema came crashing down on the pavement. It was a complete mess and builders said at the time the brickwork weighed about four tonnes.' The fin was never replaced.

Following the nationwide downturn in cinema attendance, the Yeovil Odeon was sold to Classic in 1972 and took on that name. Also in 1972, the former Odeon was tripled, as was the custom for flagging cinemas in those times. In Screen One, the old circle was extended forwards, and retained 602 seats, the main screen and the original stage. Under the circle, the area was divided into ScreenTwo (241 seats) and Screen Three (247 seats). Gaumont Kalee projectors and sound were in use in these two smaller cinemas. All of this was done while keeping Screen One open for business. The three-screen cinema officially opened on 2 November 1972 with *The Godfather*, *Joe Kidd* and *The Concert for Bangladesh*. (Scan from *Classic Cinemas* magazine, reproduced by Ben Doman)

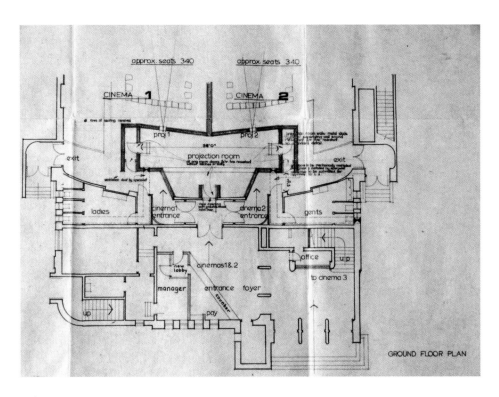

Odeon XXX

Included here are some of the architects' plans for the 1972 tripling of the former Odeon. The architects used were Benz & Williams of Eastbourne, and the drawings are dated 11 August 1972. (Plans from 1972 refit, reproduced by Ben Doman)

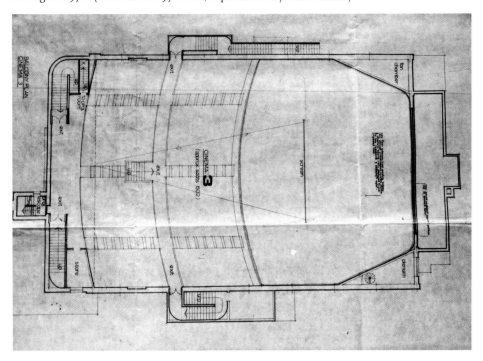

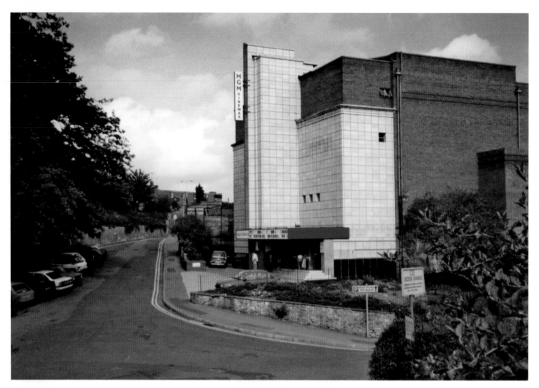

Odeon XXXI

Classic Cinemas was sold in 1986 to the Cannon Cinema Group (an American company that was newly arrived in the UK), and so the cinema changed name again, this time to Cannon. The photographs here are from 1993.

Graham Rogers was manager from 1989 to 1994, with Carole Gumm as assistant manager. They were responsible for turning the fortunes of the cinema around in 1990 when Cannon threatened to close the cinema unless Rogers could make an impressive change to its fortunes. This he did, despite the £225,000 of damage inflicted to the roof in the storms of January 1990, which forced the cinema to close for thirteen weeks.

Odeon XXXII

Projectionist Ben Doman remembers how the cinema was transformed. 'Because the insurance paid for the refit, it was done to a high standard,' he explains. 'The ceiling in Screen One was replaced with a grid that was curved to match the original design. Concealed lighting troughs were fitted on the side walls – they matched the 1937 design, but had just one colour instead of the original three.'

There was a gala reopening ceremony on 3 May 1990 – almost fifty-three years to the day after the original opening ceremony. The overhaul included a new roof and decoration throughout, plus new carpets and seats in Screens One and Two, new carpets in all public areas, and all three screens were enlarged. A new colour scheme was introduced, and suspended ceilings were installed to create a more modern look. Even the capacity was increased, with Screen One squeezing in an extra twenty-nine seats. The gala night included a free screening of *The Witches*, and on 4 May there was a day of free films for Yeovilians to tempt them back to the cinema.

Thanks to Graham's work, by 1994 the Yeovil MGM was one of the most successful in the UK circuit, as seen in the images on the next page. (Scan courtesy of Cinema Theatre Association Archive; photographs on previous page by Jack Sweet, 1993, reproduced by kind permission of the Heritage Team, South Somerset District Council)

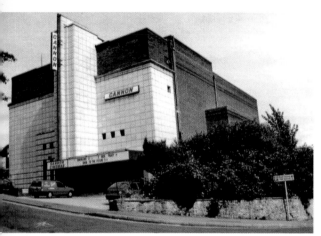
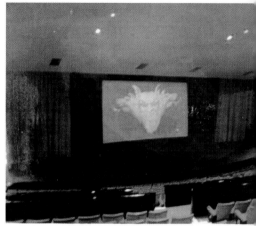

Odeon XXXIII

In the early 1990s, the Cannon Cinema Group was caught in a series of court cases, meaning the chain was taken over by lawyers and renamed MGM (part of the Cannon group), which brought yet another name change for the Yeovil cinema in 1994. Becoming an MGM also brought two more 'firsts' to the cinema.

Projectionist Ben Doman explains: 'When the name changed to MGM, we had a huge square sign fitted on the front of the building above the entrance. There were two innovations here. This was the first site to have a black background to the MGM logo (previous sites had dark blue or white), and it was a prototype for a new type of sign that had a vinyl sheet printed with the image stretched over a frame, rather than a Perspex sheet.'

At this time, the wooden front doors, which were fitted when Classic Cinemas took over in 1972, were replaced with aluminium ones taken from the ex ABC/Cannon in Basingstoke.

Ben continues: 'The Kinoton FP20 projectors had a Kinoton ST200 platter attached. This held the whole programme on one of three horizontal disks. These were run manually for several years before three second-hand Gretton Ward automation systems were fitted. This meant that one of the four projectionists was made redundant. Screen One had a Dolby CP55 stereo sound system fitted, and Screens Two and Three had second-hand Phillips OMA amplifiers. These were quite innovative when they first came out, being modular and the first transistorised cinema amplifiers. These took quite a bit of tweaking to get the optimum sound out of them. *Jurassic Park* had a DTS digital sound logo printed on the film, and when the previews played in Screen Two, people came out saying how fantastic the digital sound was. We didn't like to tell them it was only mono, and just 12 watts at that. The average car stereo had more power!'

Ben Doman explains that the revamped Screens Two and Three had floating screens fitted with fire-glow bulbs creating a halo around the inside edge of the screen. Both screens had an effects projector that had glass wheels. This projected patterns on the screen between shows. 'If we were in a particularly evil mood on a Friday or Saturday night, we would fit an oil wheel (the heat from the bulb would heat the coloured oils in it and they would ooze like a lava lamp) with a rotating beveled glass wheel in front,' he explains. 'You could see the people who had a little too much in the pubs before the late shows turning green!'

Ben adds: 'When the Automaticket machines were made redundant and a computerised box office fitted, the box office had to be extended to accommodate three windows. This was because it took longer to issue a computer-generated ticket than it did to use the manual machines.'

The photographs show the cinema's exterior in 1989 and Screen One in 1989. (Photographs by Ben Doman, 1989)

Odeon XXXIV

In July 1995, after Virgin briefly bought the Cannon/MGM chain, the Yeovil cinema was up for sale yet again. On 2 June 1996, it was bought by ABC and duly took the name it would keep until its closure in 2001.

The cinema celebrated its diamond anniversary on 10 May 1997, which was extra poignant for one member of staff, who had worked there for the entire sixty years. Ben Tucker became projectionist at the Odeon in 1937 when he was just seventeen. During his sixty years with the cinema, Ben also met his wife, Christine, there. The first film Ben ever screened was *Victoria the Great* in 1937.

Ben officially retired in 1987 but carried on working at the cinema as a handyman. In 1997, he said: 'Four years ago I had a stroke and was in hospital for two weeks. After I'd recuperated at home for a month, I asked to come back. I couldn't sit at home doing nothing and fortunately, at my age, I can still do a bit of work.'

Ben Doman confirmed: 'There was always a very dedicated team at the cinema, both in the projection room and on the floor. When the cinema was busy, we would all pitch in. If we were free to, the projectionists would go down and help clear the rubbish between shows or assist with seating.'

The resilient cinema closed for the very last time on Easter Sunday 2002, following the opening of the Cineworld multiplex. The former Odeon is now a furniture shop, which opened on 3 January 2004.

Coda 1

When the cinema closed, it was gutted of all cinema fittings, many of which were unfortunately dumped in a skip as no suitable home could be found. However, a local man called Andrew Masterson tells me: 'I managed to talk to the workmen who were ripping out the seats, smashing them up and putting all the metal parts on one lorry and all the cushions on another. Ten minutes later I returned with six lots of fish and chips for them, and in return they helped me to rescue some seats and a few other artefacts. As a result, I was able to reconstruct my very own little Odeon in my spare room. I now spend many hours in there watching movies, and old Pearl & Dean advertisements.'

Coda 2

A June 2007 report from South Somerset District Council included the following ominous text: 'The old cinema building does not present an attractive frontage to Court Ash. There is an aspiration to redevelop the old cinema site with a mix of retail and residential land uses. Given the recent refurbishment of the building for large-scale retail, this phase is unlikely to come forward in the next ten years.' There are only four years left until 2017.

An advance booking card for MGM Cinemas. (Photograph by Ben Doman, 1989)

This Is The Foundation Stone Of Yeovil Town Station Which Stood On This Site.
The Station Was Closed In 1967 And Demolished In 1973

Cineworld I

From its roots in the music hall and travelling sideshows, cinema rapidly grew into an entertainment that required its own palace in which to be shown – an opulent experience, housed in grand, exotic buildings, with plush carpets, sweeping staircases, neatly uniformed staff, and every possible indulgence (ice creams, drapes, chandeliers). The rise of television from the 1950s started the slow death knell for cinema as we used to know it, though in recent years the medium has enjoyed resurgence. For many reasons, we have the American multiplex to thank for this, which made its first appearance in the UK in 1985 in Milton Keynes. However, while the multiplexes helped to revive the flagging film industry, they didn't do much for the fortunes of most of the original cinema palaces, which are now almost extinct beasts.

At the opposite end of Yeovil to the Odeon was a sprawling and ugly concrete car park. This stood on the site of the former Yeovil Town railway station, which opened on 1 June 1861 and closed on 3 October 1966. In the years between 1966 and 2001 there was great debate about the best ways to bring the space to life and to attract people to use that end of town, which had become rather neglected, especially after the 1980s when shops and Yeovilians began to gravitate towards the other end of the town leaving this end of Yeovil as a neglected and out-of-date eyesore. All that remains now is the dated foundation stone, pictured.

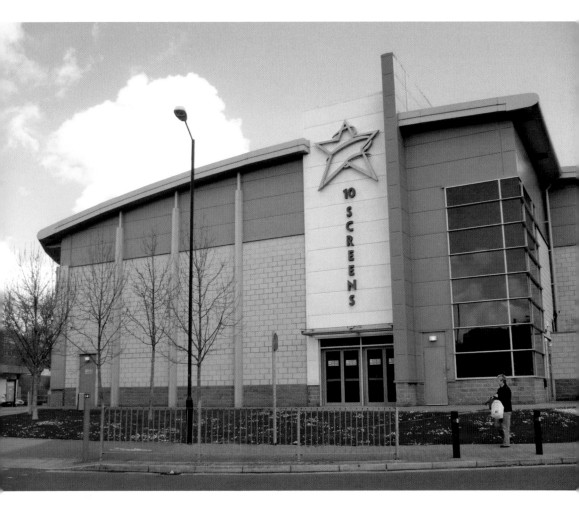

Cineworld II

In May 1992, the *Western Gazette* wrote: 'A massive multi-million pound leisure park is being planned for Yeovil ... [to] give the town its first custom-made recreation complex'. Ambitiously, this article suggested the complex would include a stadium for music and sports, an ice rink, a six-screen Cannon cinema, a two-storey bowling alley and more. It proved to be a long time before anything actually happened.

Building work for the Yeovale Leisure Park began in autumn 2000, after nearly a decade of discussion. The complex included chain restaurants, a gym, bowling alley and a ten-screen multiplex Cineworld cinema, as well as a huge car park.

The complex was heavily delayed during construction and finally opened in April 2002, complete with the Cineworld designed by Unick Architects. It has 1,897 seats across ten screens, and was the twenty-sixth cinema in the Cineworld chain, which was formed in 1995. As the picture shows, it is devoid of any advertising for films, and bears just the Cineworld logo; only the lettering '10 Screens' belies that it is a cinema.

Cineworld III

It seems very sad to me that after the grand designs of the 1930s – when cinemas were palaces with every creature comfort, and were destinations of luxurious indulgence – Yeovilians who want to see a film at the cinema have no choice but to sit in formless, identity-free boxes to watch films on screens little bigger than some home televisions. Seemingly Unick Architects spared little thought for creating a visually impressive building that they and the town could be proud of, and the interior designers ensured that the space was, at best, functional. The picture below shows the entrance to the cinema, which is a wall of glass slotted between a gym and bowling alley, decorated only by an electronic board displaying the name of current films. At the time of writing, Cineworld is the only cinema in Yeovil.

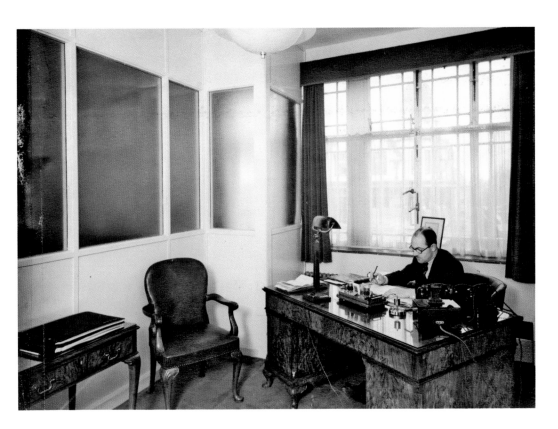

Leslie Kemp I

Leslie Kemp (1899–1997) was born in London, but spent his later years living at various addresses in Yeovil, after working in Canada during the 1940s and 1950s. Kemp was one of the most respected British architects to work on cinema designs in the 1930s, after qualifying from the Architectural Association in London in 1922.

Although he never designed any of Yeovil's cinemas, Kemp (along with business partner Frederick E. Tasker) is best known for a cinema that opened in 1936: the Studios 1 and 2 in Oxford Street, London. What made Studios 1 and 2 unique was that they were the world's first example of two small cinemas built one on top of the other.

However, while the Odeon may be Yeovil's best-known cinema, Kemp tells a different story of Oscar Deutsch's attention to detail than the version that is commonly portrayed. Kemp recalled in 1988: 'Deutsch didn't want architects. He had a man named Grenville (he was just an engineer) who used to write out all the specifications – the seats had to be spaced a certain distance apart and all that sort of business ... Deutsch was cut-throat ... Did I tell you the way he operated? Deutsch would go to Yeovil, for argument's sake, and he'd get hold of a doctor or businessman and say, "Now I'm going to build a cinema in Yeovil. If you want to, you can buy shares in it." He started life in Birmingham, selling old iron – but he never put more than £100 of his own money in any theatre. The way he operated was, he'd come and meet you and me, and then he'd get hold of a builder. Now people were scrambling for work in those days. These days you hear so much about unemployment but after the First World War there were two million unemployed and builders were screaming for work. So Deutsch would get hold of a builder and say, "You can have this contract provided you don't ask me for any money until after you've done over £5,000 worth of work." And then he'd go to an insurance company and say, "Now listen, I've got so much capital, will you lend me the rest?" I never did any work for Deutsch.'

Kemp is pictured here in his London offices in the 1930s. (Photograph from Kemp's Album, 1930, courtesy of Richard Norman)

Leslie Kemp II

It's not clear exactly why Kemp ended up living in Yeovil, but he is known to have had a house on Penn Hill in 1968, and later a flat on Hendford Hill (this picture shows him in this flat in 1977).

Ron Knee interviewed Kemp in 1988, and explains he was rather a transient man. 'When Leslie came back from Canada, he moved all over the place, sometimes staying only a few months. He returned to the UK in 1960 and lived in Ealing, before moving to the West Country because he had friends there; although he lived for six months with his daughter Suzanne in Bradford Abbas before moving to Yeovil. Kemp always rented and moved house regularly, often for no particular reason. Middle-class people from the 1920s and 1930s rarely bought property. He always worked from home on his return to the UK and did not rent any offices.'

After Kemp's wife died, he moved to Bramley House Care Home in Mere, Wiltshire, where he spent his final years, before passing away in 1997. (Photograph from Kemp's Album, 1977, courtesy of Richard Norman)

Conclusion

Between the internet, games consoles, DVD players and home cinema systems, there's a lot to tempt people to stay at home for entertainment. The habit of 'going out to the pictures' seems old-fashioned. And if the newer cinema buildings no longer offer the luxury or indulgence enjoyed by customers in the 1920s and 1930s, maybe this is to be expected. Instead, contemporary cinema-goers are faced with ugly buildings, staff in branded baseball caps, and a range of expensive, fatty food options.

However, it says something about the long-held enthusiasm for going to the pictures by Yeovilians that, apart from the Central, none of the cinemas were left empty for long or allowed to run into dereliction, as happened in many parts of the UK. Even though six of the buildings no longer operate as cinemas, the former buildings are now shops (Assembly Rooms, Odeon), a nightclub (Gaumont) and a warehouse (Globe). Only the Central was demolished, and the Cineworld continues to serve as a cinema.

As an aside, Yeovil almost had an eighth cinema: in the 1930s, there was talk of redeveloping the site of the old Castle Inn on Middle Street into a state-of-the-art picture house. However, in the end, the site was developed into a Woolworths and, more recently, Primark.

The Multiplex Delusion

The multiplexes on out-of-town complexes put cinemas into a kind of no man's land, neither in the heart of things nor out in the sticks. Cinema has become a retail experience, not a social experience. You now drive to a retail park and you buy your car park ticket. Before the film, maybe you buy a meal in one of the chain restaurants outside, or spend some money in the arcade inside the cinema foyer. Often, tickets are bought at the same counter where popcorn, drinks and other foods are sold, and you might even need to cough up for 3D glasses (because the film you want to see is now only available in headache-inducing 3D, even though you would rather see it in 2D).

It doesn't matter how many screens a multiplex boasts, because inside each room is an identical box. You could be anyone, anywhere ... but not in the way of the 1930s, where the movies could transport you to exotic Hollywood or thrill-inducing space. Multiplexes offer an illusion of choice, but often two or three blockbuster films are shown on rotation on several of the screens, meaning there isn't as much choice as you are led to believe.

Cinema in the 2010s has been repositioned in the minds of the audiences. Younger cinema-goers know nothing except the multiplexes, but older audiences (even those in their late twenties or thirties) remember going to a surviving super-cinema from the 1930s and the indulgence that it was. When I was a child in the 1980s, going to the cinema was still considered a treat, something you really looked forward to.

Speaking in 2012, Jack Sweet reflects on how cinema-going has changed in the decades he has lived in Yeovil:

> Cinema was something that all people could enjoy: husbands, wives, teenagers, children, it was something for everyone. It was a family affair. It was an evening out to look forward to. At the time, no-one ever thought the cinema would end. But then you go fifty years before that and what did people do? They sat around a piano and sang songs in gaslight. Each era has its own feeling. Being nostalgic is the worst thing you can do, because you edit out the bad stuff. Cinema was fun, that's how I'd sum it up.

I still regularly go to the cinema, but I do my best to avoid the multiplexes. I choose to support independent cinemas, old-fashioned cinemas, art house cinemas, or any cinema building with character and staff with personality. There are still quite a few to choose from if you look hard enough.

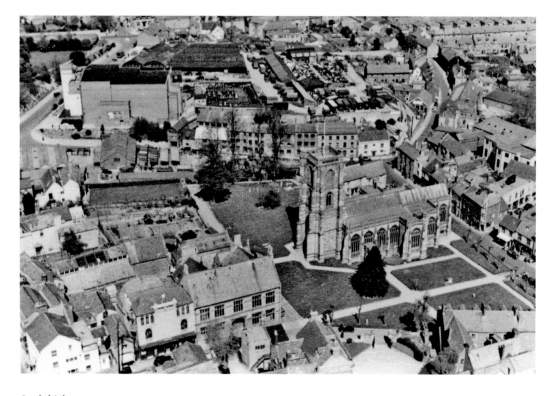

Aerial View
An aerial view of Yeovil in 1945 showing the Central Cinema (bottom left) and the Odeon (top left). The roof of the Assembly Rooms is visible just behind the Central Cinema.